BOBBY FISCHER

HARRY BENSON

EDITED BY GIGI BENSON

powerHouse Books
BROOKLYN, NEW YORK

BOBBY FISCHER

Published in the United States by
powerHouse Books, a division of
powerHouse Cultural Entertainment, Inc.
37 Main Street, Brooklyn, NY 11201-1021
telephone: 212.604.9074, fax: 212.366.5247
email: bobbyfischer@powerhousebooks.com
website: www.powerhousebooks.com

First edition, 2011
Library of Congress Control Number: 2011925721
Hardcover ISBN 978-1-57687-581-0
Printed and bound through Asia Pacific Offset
Book design by Triboro

A complete catalog of powerHouse Books
and Limited Editions is available upon
request; please call, write, or visit our website.

10 9 8 7 6 5 4 3 2 1

Printed and bound in China

To my wife, Gigi, who painstakingly edited the photographs, and without whom this book could never have been published, I dedicate this book.

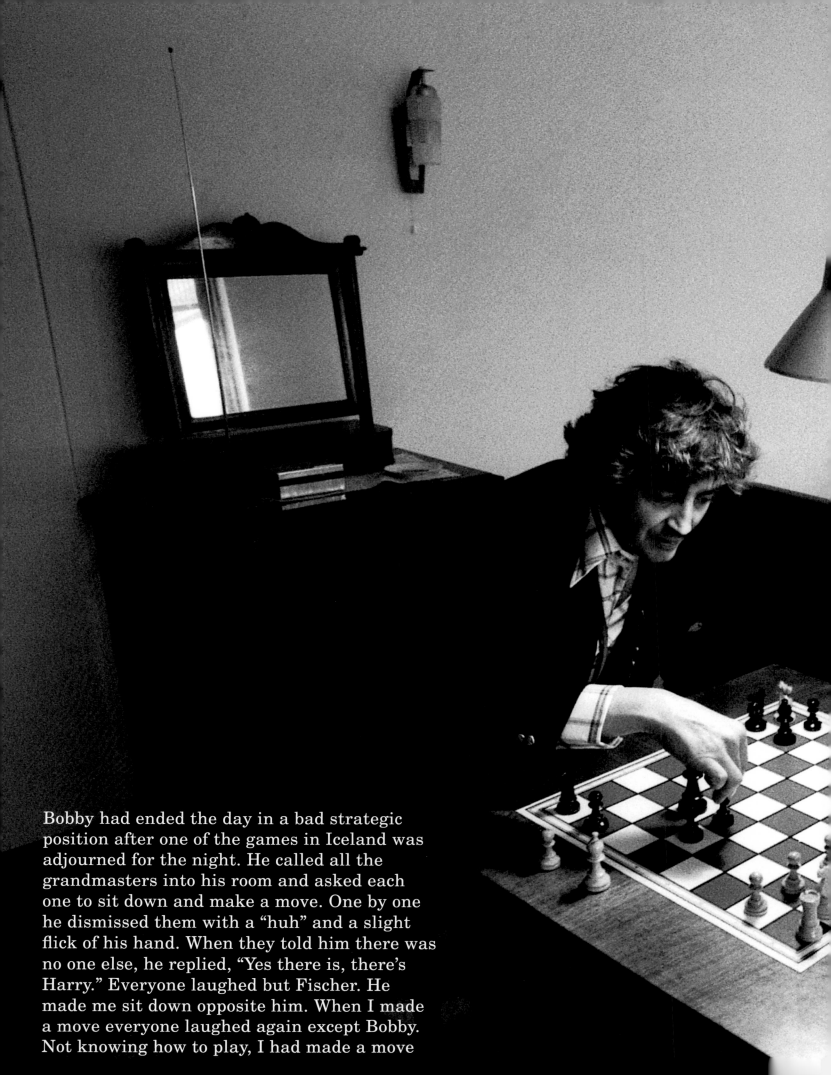

Bobby had ended the day in a bad strategic position after one of the games in Iceland was adjourned for the night. He called all the grandmasters into his room and asked each one to sit down and make a move. One by one he dismissed them with a "huh" and a slight flick of his hand. When they told him there was no one else, he replied, "Yes there is, there's Harry." Everyone laughed but Fischer. He made me sit down opposite him. When I made a move everyone laughed again except Bobby. Not knowing how to play, I had made a move

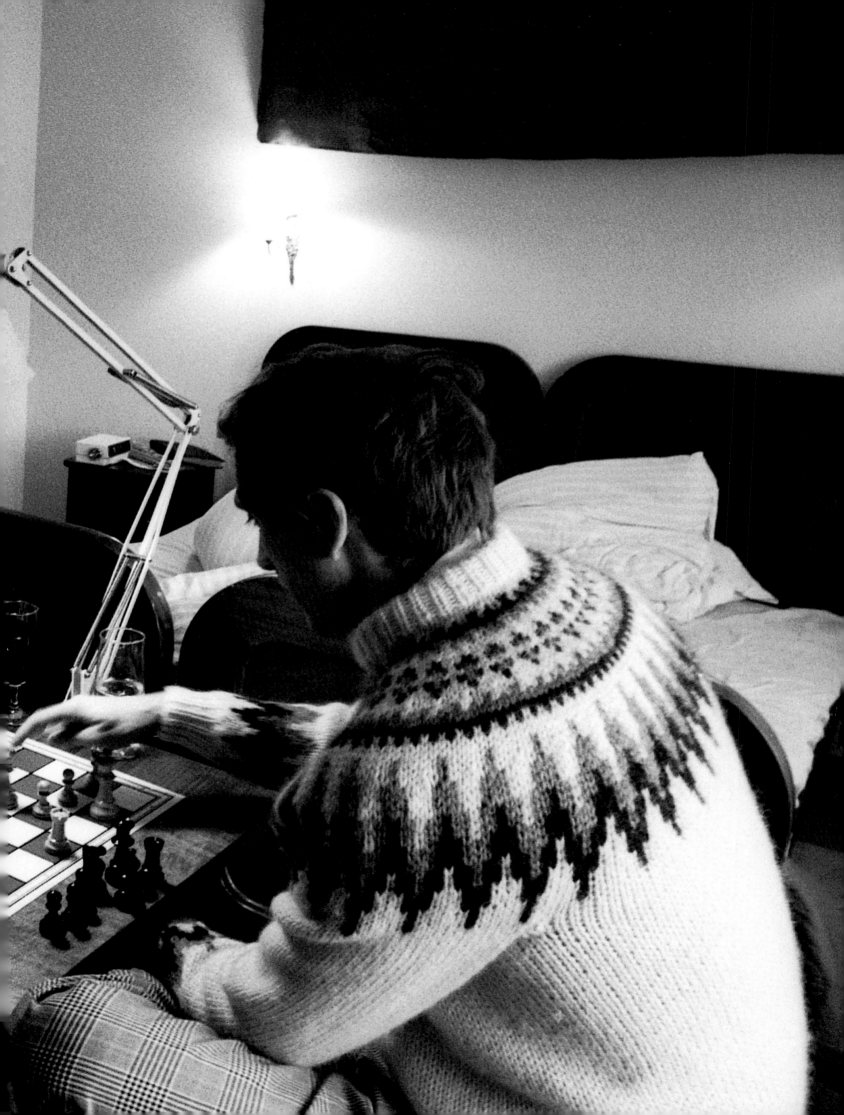

BUENOS

NOVEMBER 1971: Bobby Fischer had defeated former World Chess Champion Tigran Vartanovich Petrosian, the last opponent in the 1971 Candidates Tournament standing in Bobby's way before he could play for the title of World Champion. *LIFE* magazine's Richard Stolley assigned the story to staff writer Brad Darrach and photography editor Ron Bailey assigned me in the hopes that we could get an interview and some photographs of the elusive genius. I was given the job because another photographer had dropped out. He was out and I was in. It was the same story when I got the assignment to cover the Beatles in Paris. I replaced another photographer at the last minute. Interesting how chance played the same roll in my getting both assignments.

Brad and I flew to Buenos Aires and checked into the hotel that Bobby was staying in. My first meeting with Bobby was at about one o'clock in the morning. He wanted to go for a walk. He liked to walk at night and sleep during the day. As we walked he would stop by a lamppost, bring out his pocket chess set, play a few moves under the flickering light, and then move on. He hardly spoke at all. Stopping to sit on a particular park bench, he told me he had sat there often during the recent match against Petrosian. Being skeptical, especially of journalists and photographers, our first meeting was brief

but I sensed that Bobby was secretly pleased with the idea of having the attention of a major magazine focused on him.

Everyone knew his life had been narrowly and totally focused on chess, and it was obvious he was extremely guarded. To say he was lacking something in the social graces was an understatement. He seemed a nonconformist by default.

I think the reason Bobby and I got along so well was that I knew absolutely nothing about chess and wanted nothing from him but to take interesting pictures to send back to *LIFE*, which was published weekly in those days.

The spare bed in Bobby's hotel room was piled with rumpled clothes, boxes, newspapers, and magazines. A chessboard was set up near the window. He had large, strong hands. Watching his nimble fingers move the chess pieces at lightening speed was incredible. He could think 25 moves ahead and told me he would "crush Spassky" when they met. He repeated that phrase many times when we spoke about the anticipated, upcoming title match.

Bobby felt very at ease with animals and children, but not with adults. He was fascinated by the Argentine ponies and was delighted with himself for riding one without falling off. Animals were somehow drawn

S AIRES

to him. Sitting in the grass, dogs would come up and sit next to him. On a ranch outside Buenos Aires, he kissed a beautiful collie named Ruby on the mouth and would stroke the fur of any dog that came near.

The Argentine children all knew who he was and would gather around as Bobby, completely engrossed, played a game against himself in a park in Buenos Aires. Bobby was very patient and extremely pleased to show the children his chess moves, yet he dismissed most of his seconds and grandmasters with a flick of his hand, and when they had left the room he would say to me, "They're morons, Harry, morons."

We passed an amusement park almost every day on our walks. Bobby wended his way through the hall of mirrors and told me, "Harry, it can be scary in there." Bobby even rode the children's airplane roundabout and took it very seriously. It was as if he had never done it before.

Hand-made products from the local craftsmen interested him, and he showed me a pair of shoes that had been made-to-measure. He told me he liked picking out the leather. When I told him I liked his new shoes, he seemed pleased to receive my compliment.

Bobby liked the South American custom of eating late at night and would inhale an

enormous Argentine steak followed by lovely fresh strawberries and cream. I honestly can't remember Bobby drinking (liquor). He was dead serious about getting into mental and physical shape. He would talk about the Russians' cheating, and I remember Bobby repeating once again, "I'm going to crush them, Harry, crush them."

After Bobby's win in Buenos Aires there was an enormous amount of attention focused on him, as the Cold War between the U.S. and Russia was at its height, and the next step for Fischer was to play the World Champion Boris Spassky. The pressure was on. The newspapers and television's nightly newscasters began referring to the upcoming match in Iceland as the "Match of the Century," and it was. Headlines like "Fischer vs. Spassky: A Major Struggle in the Cold War," were splashed across the newspapers. As chess was played in every city and hamlet in Russia, they certainly didn't want to lose the title to some upstart from New York. With anticipation building, my photograph of Fischer made the cover of *LIFE* on November 12, 1971.

When Brad Darrach and I left Buenos Aires, Bobby agreed to see us while in training for the title match, at Grossinger's in upstate New York. We became the only outsiders Bobby would talk with.

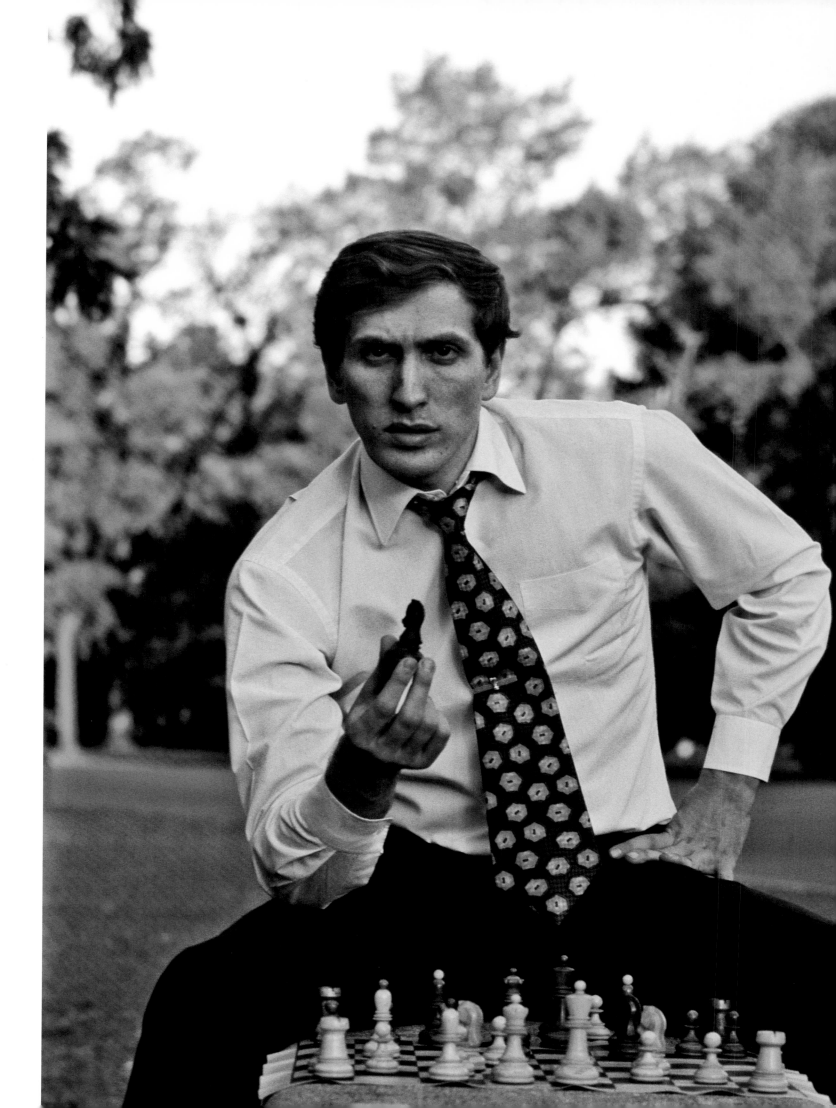

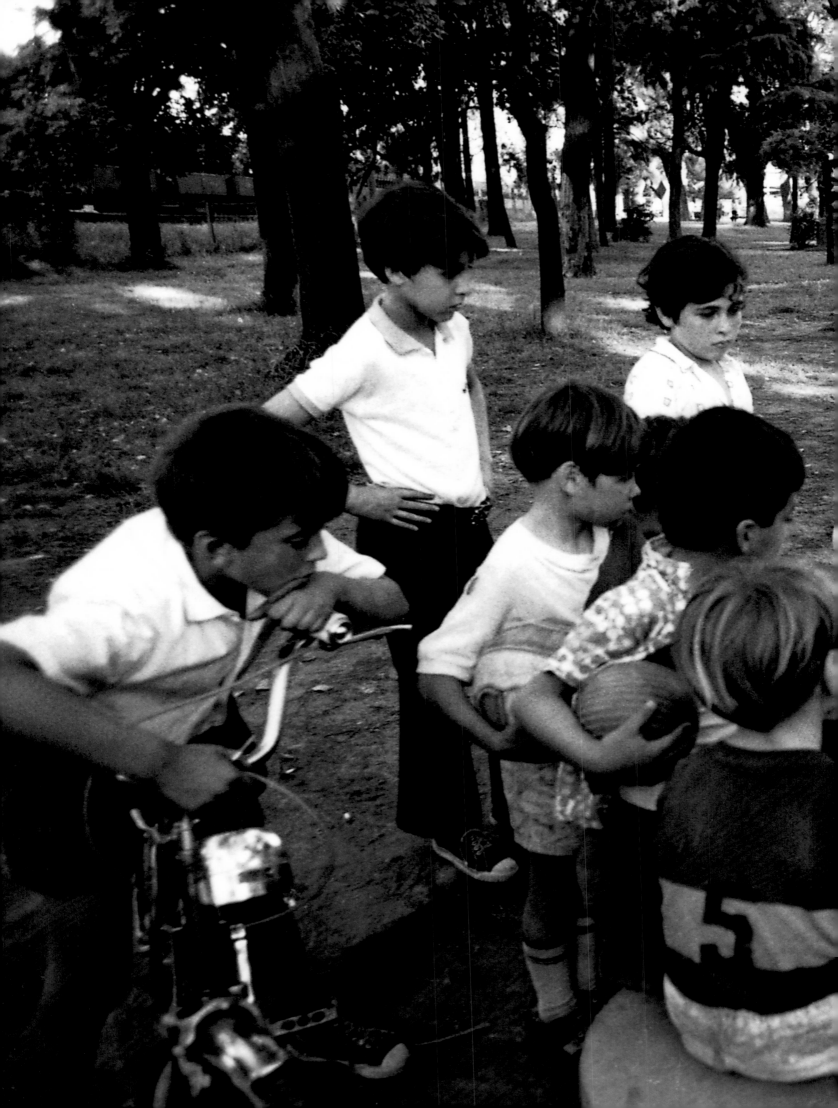

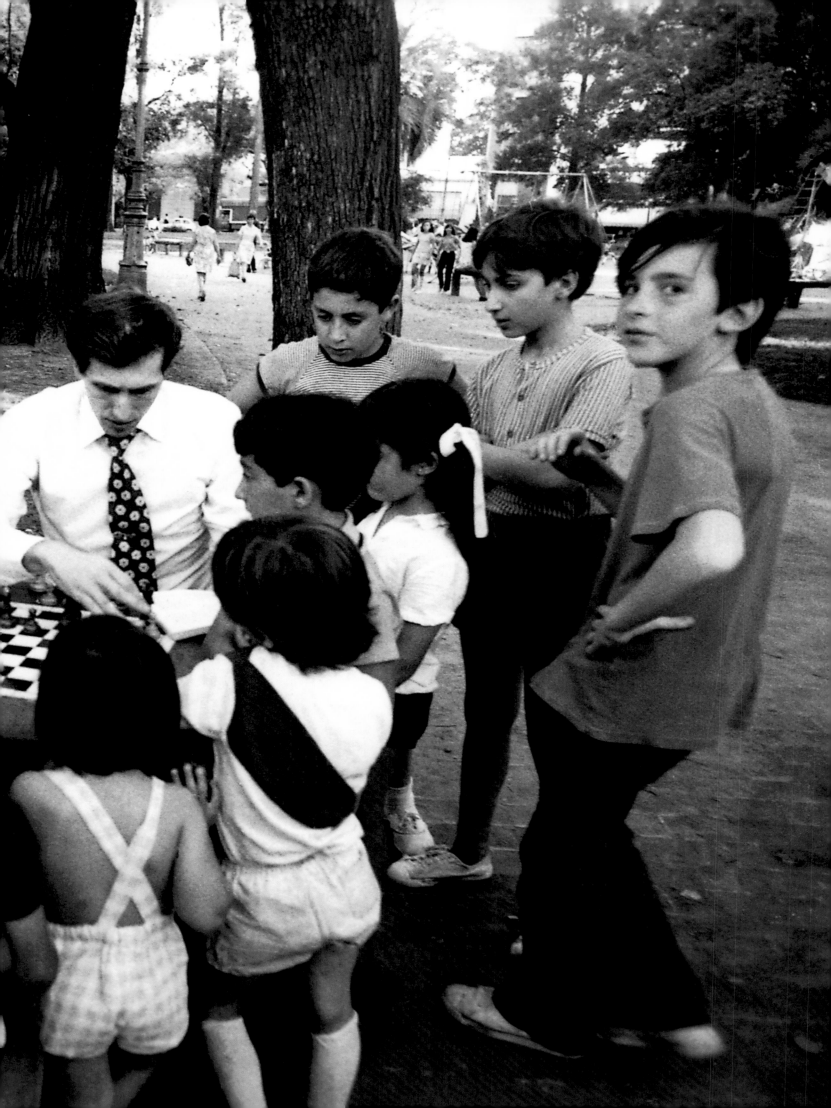

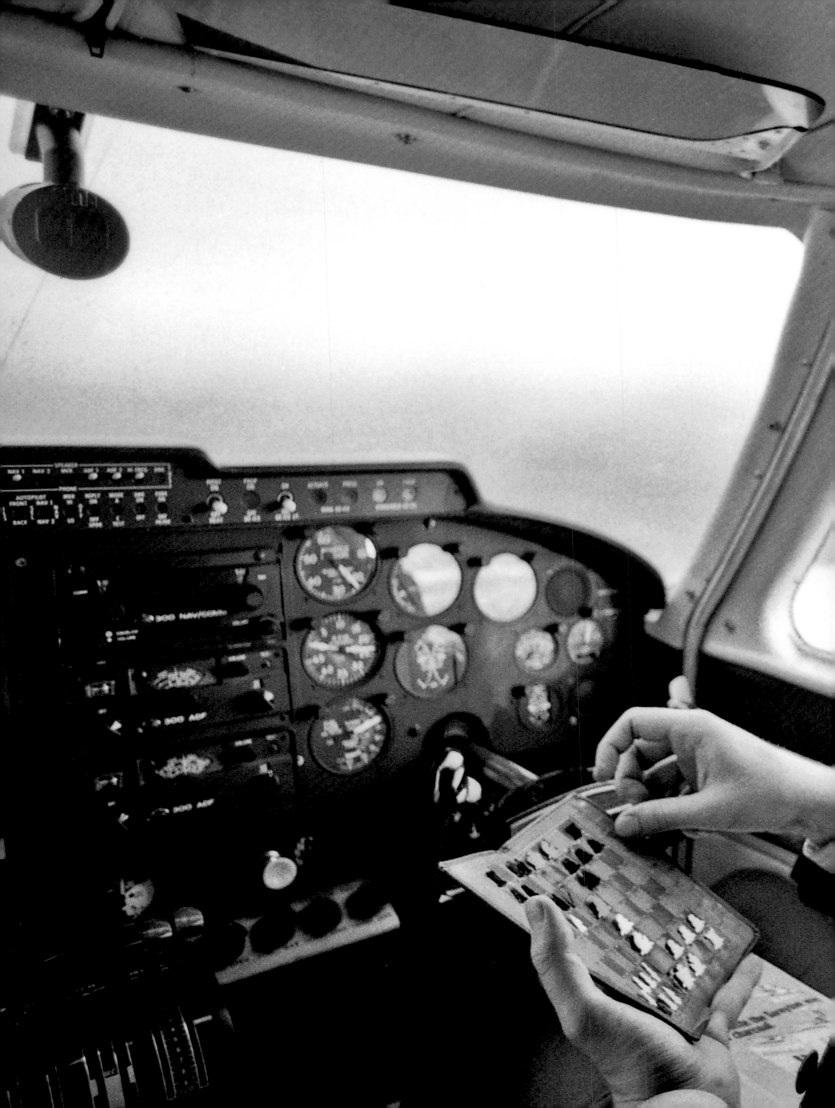

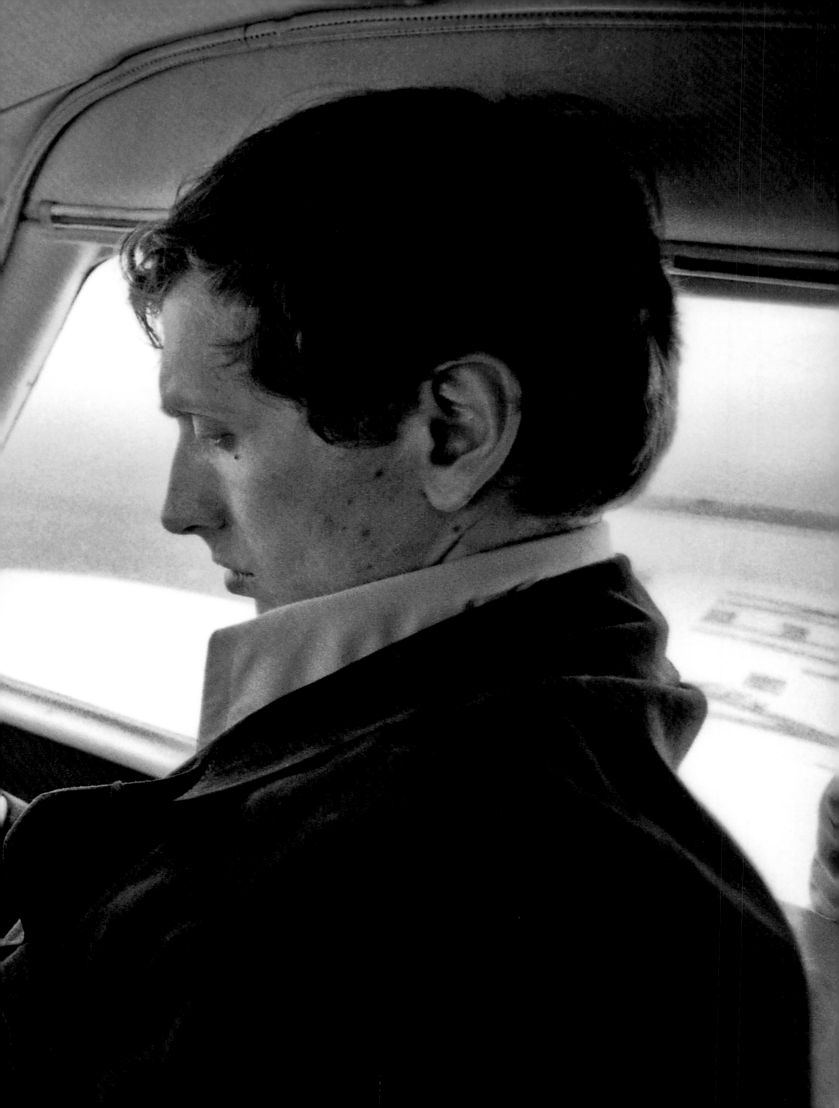

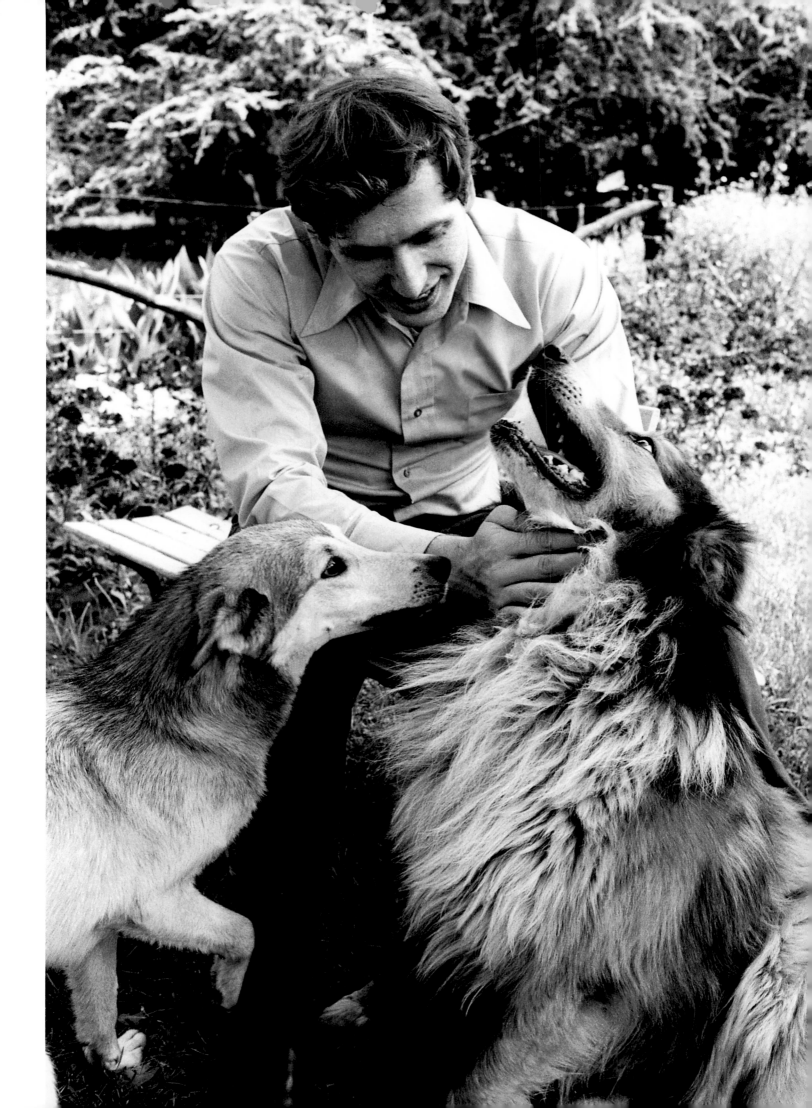

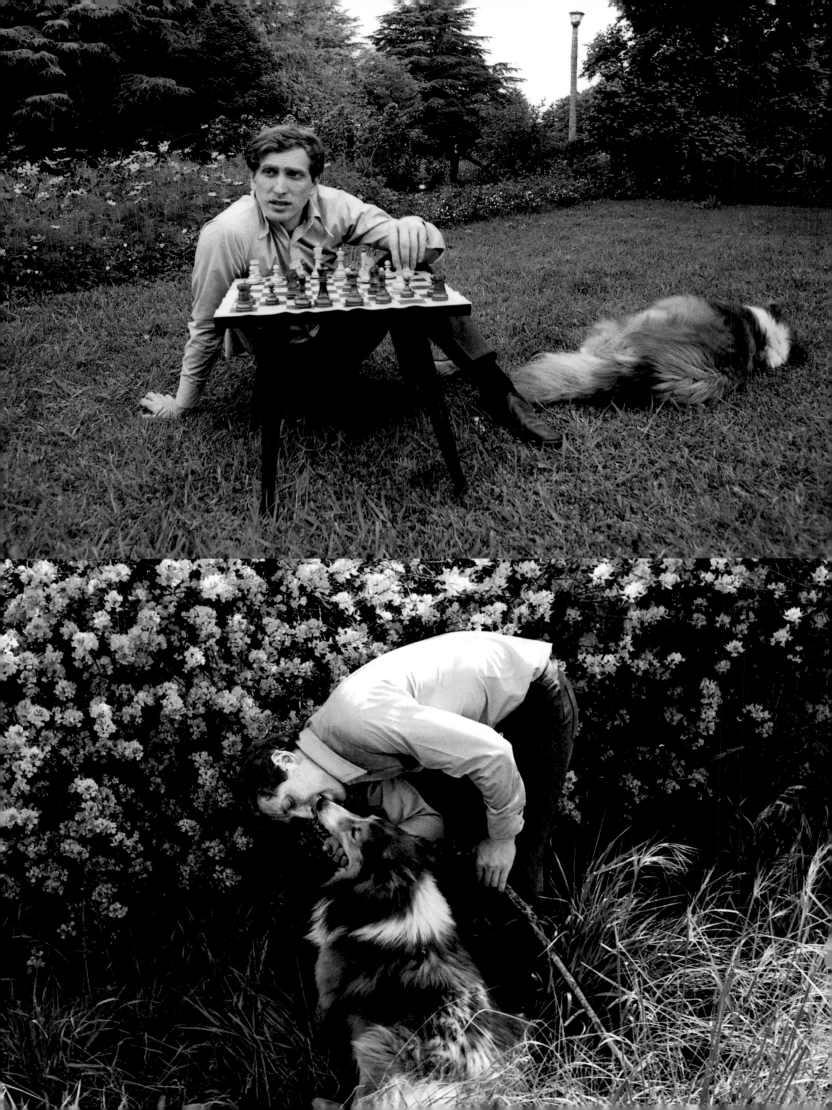

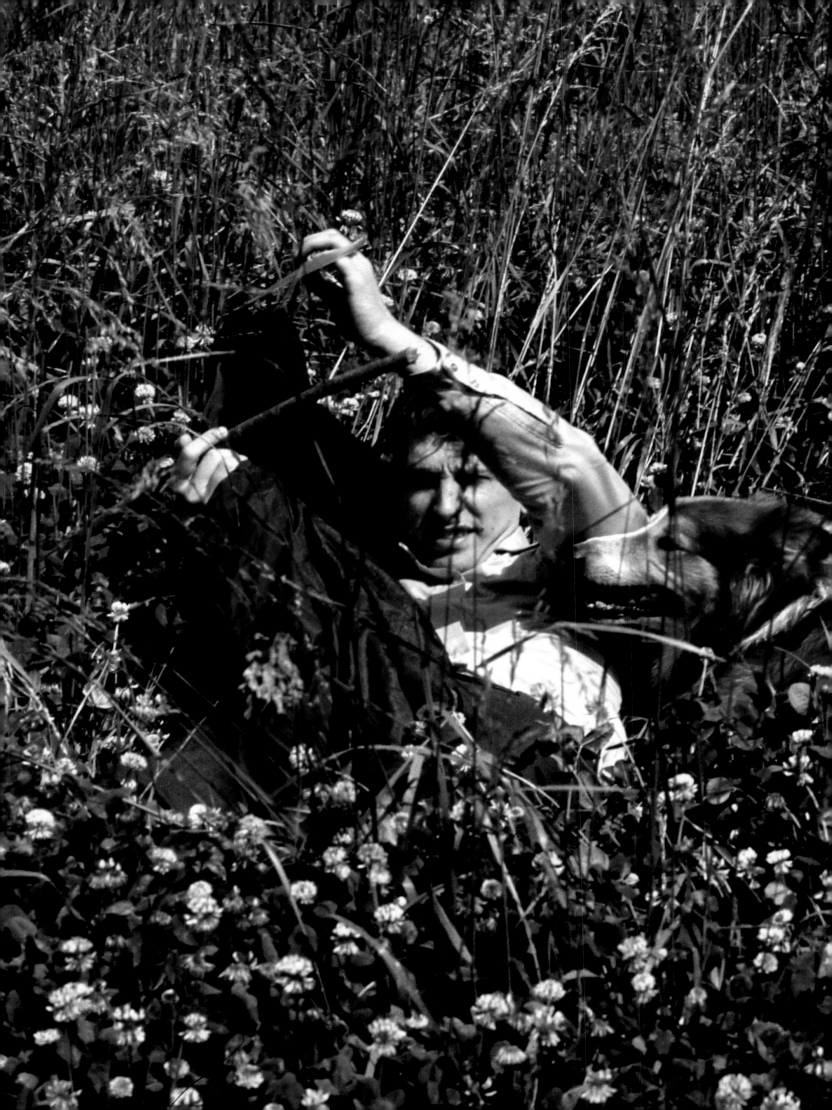

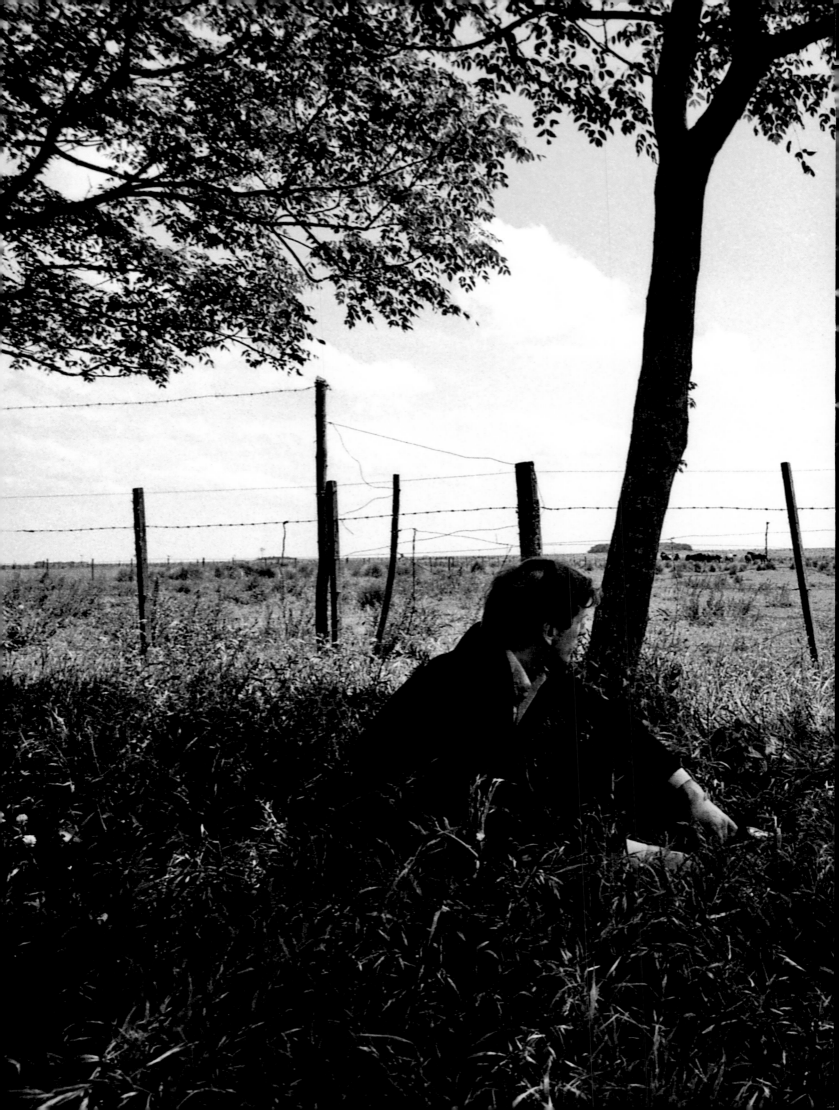

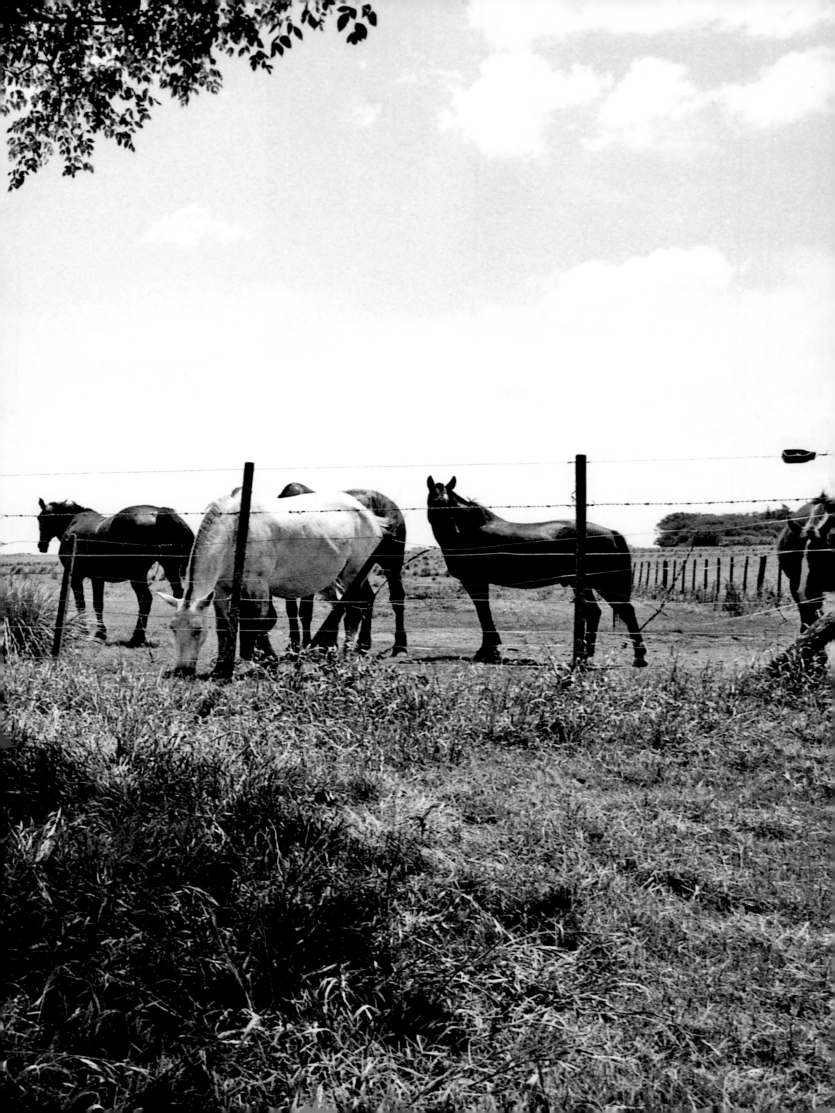

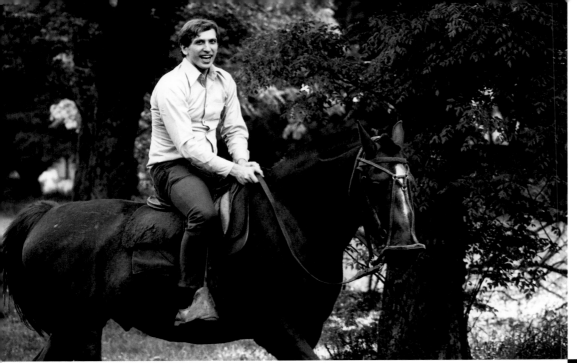

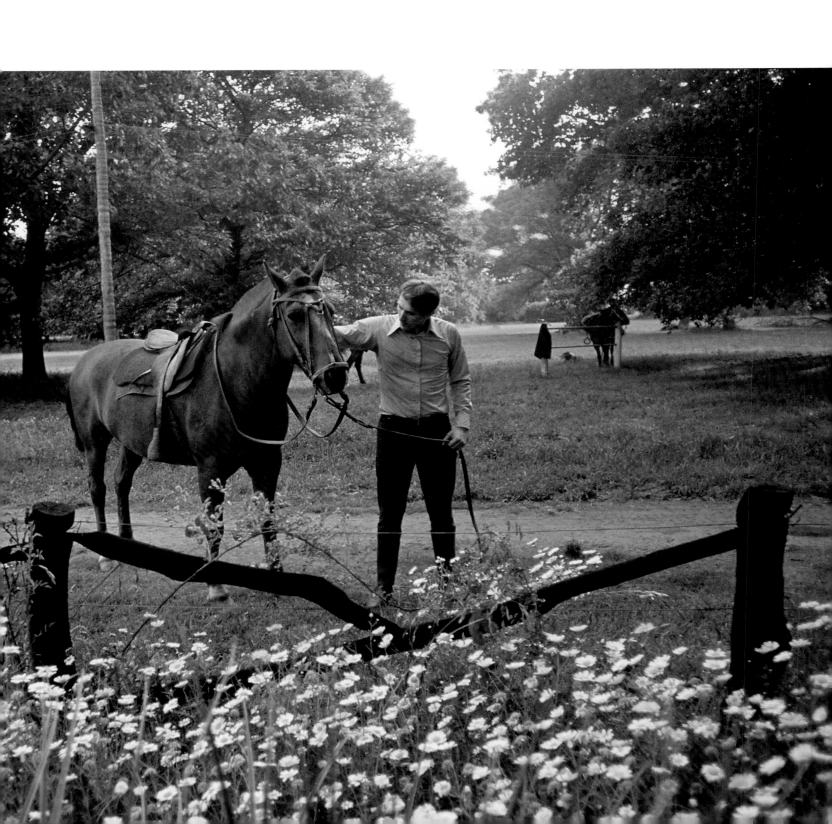

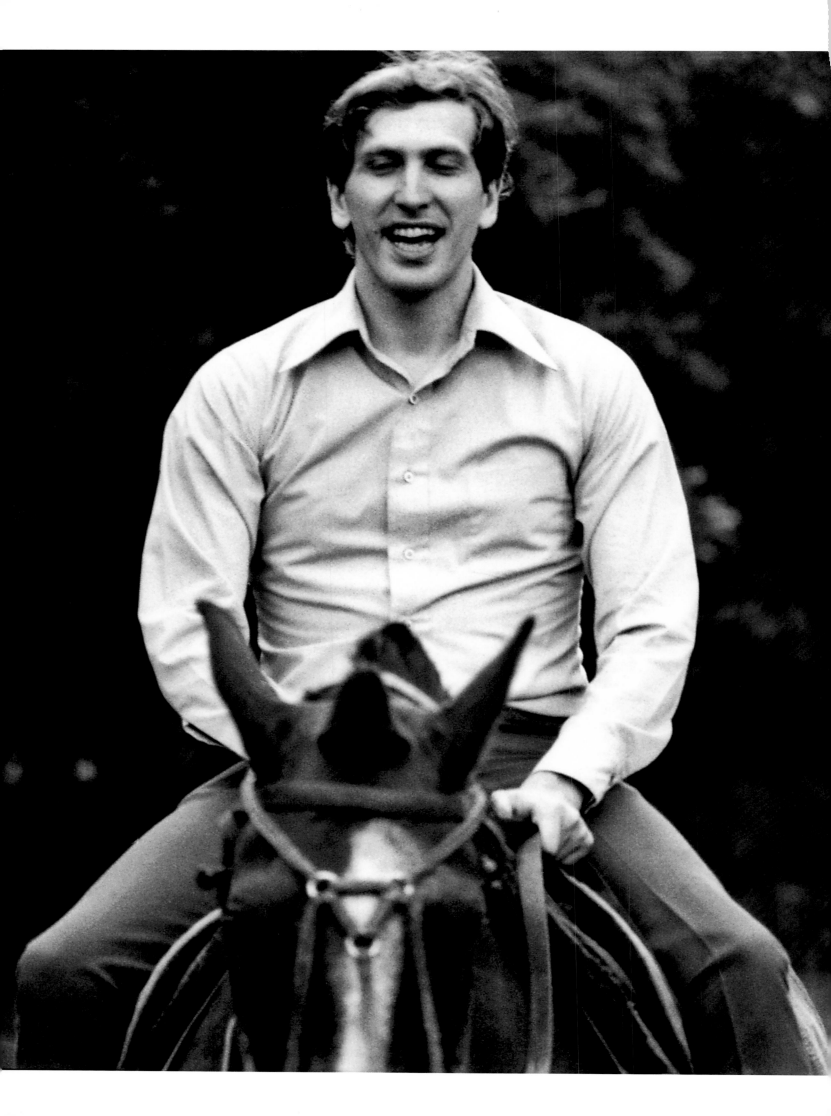

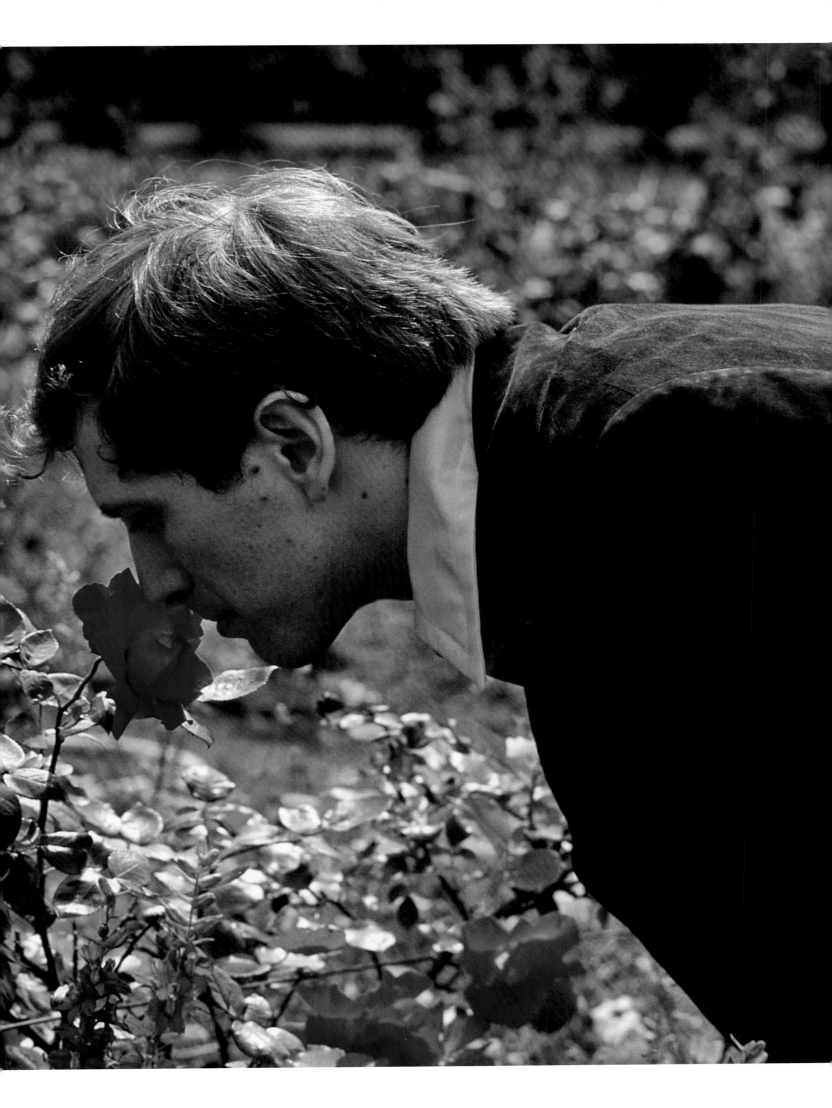

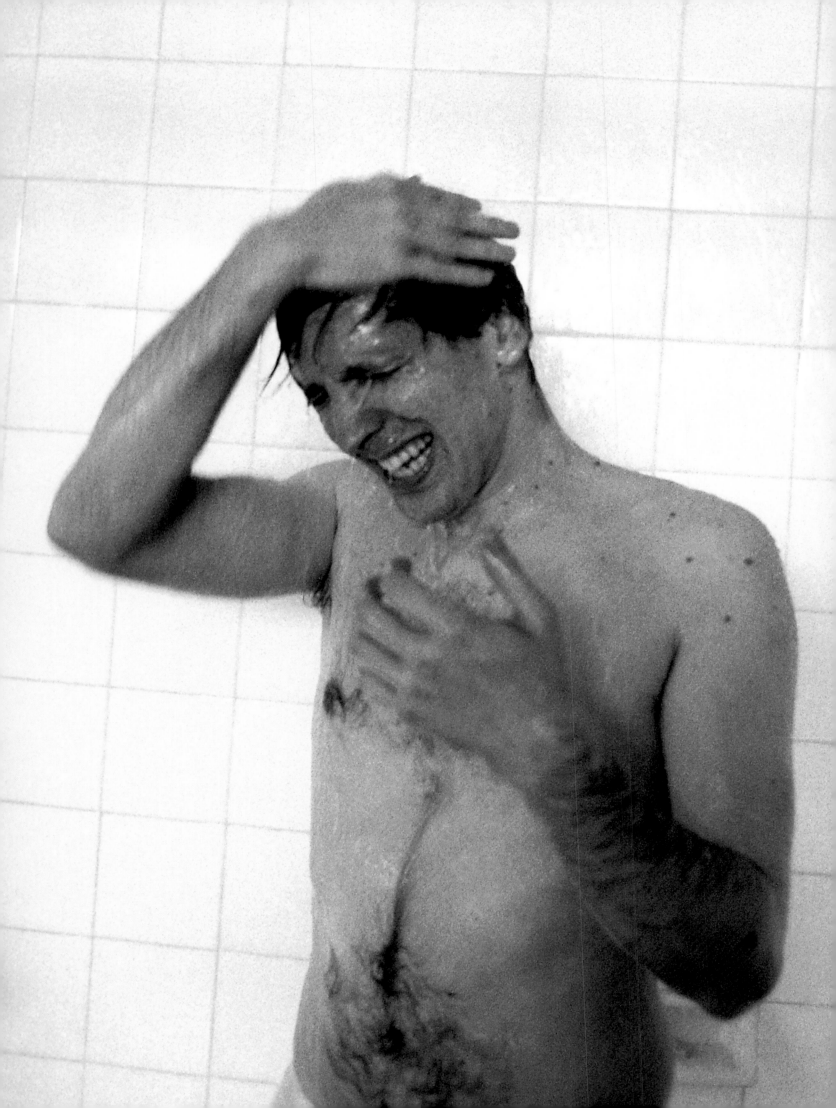

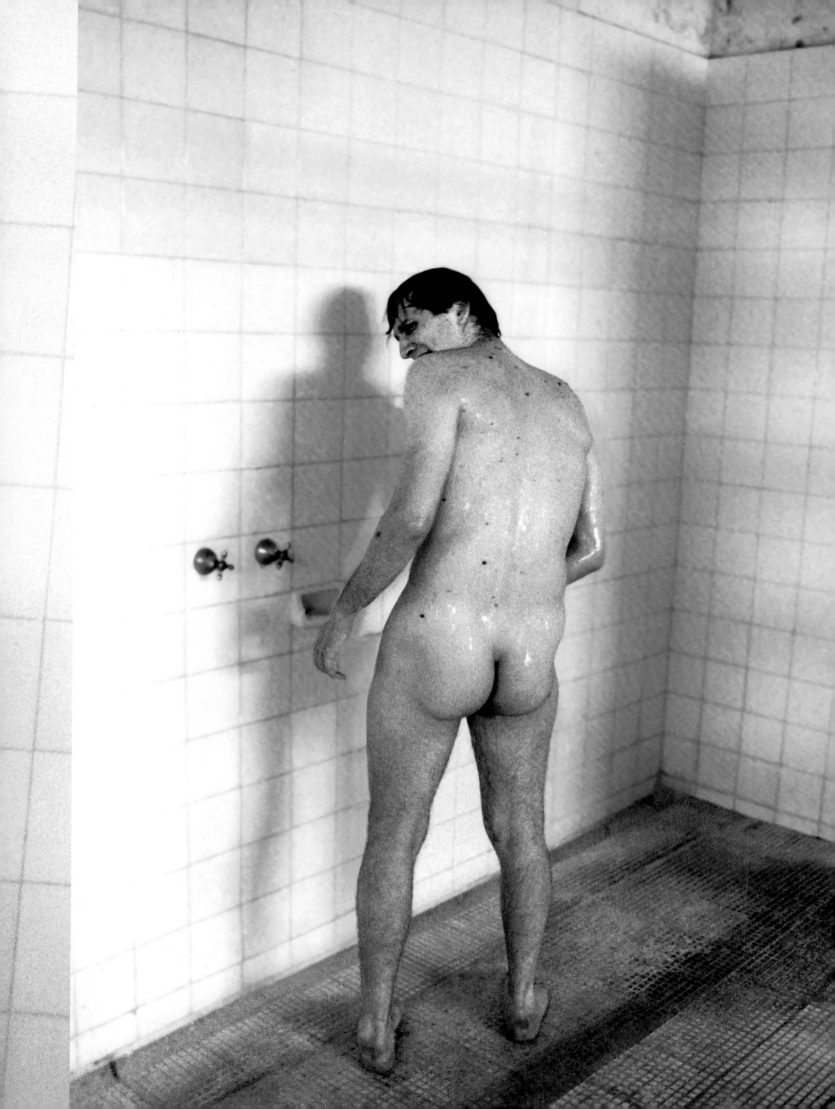

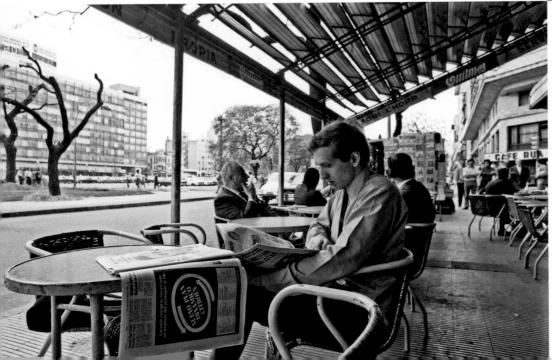

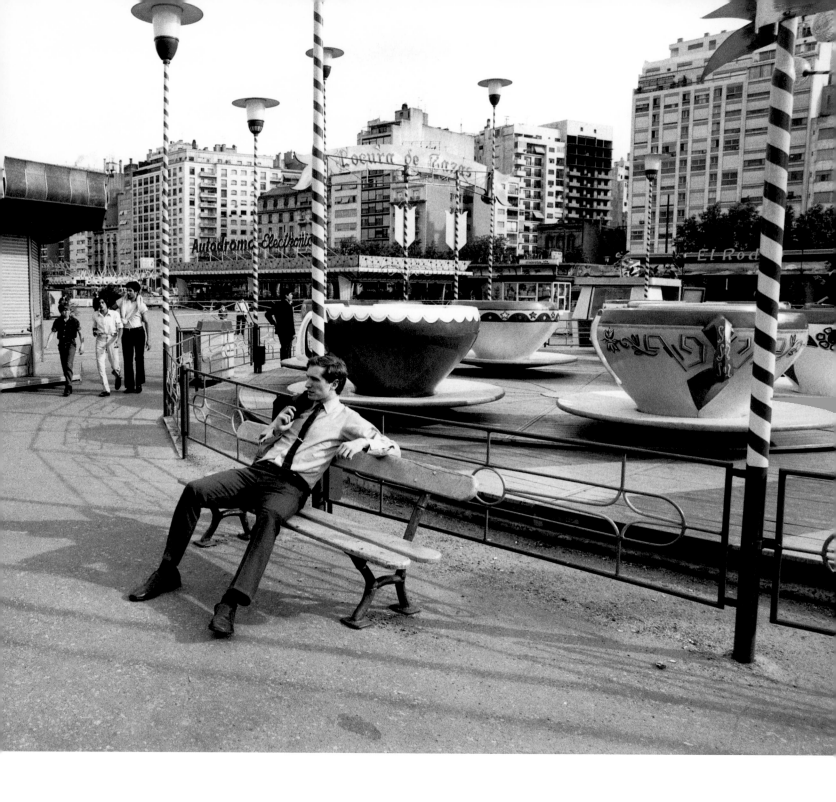

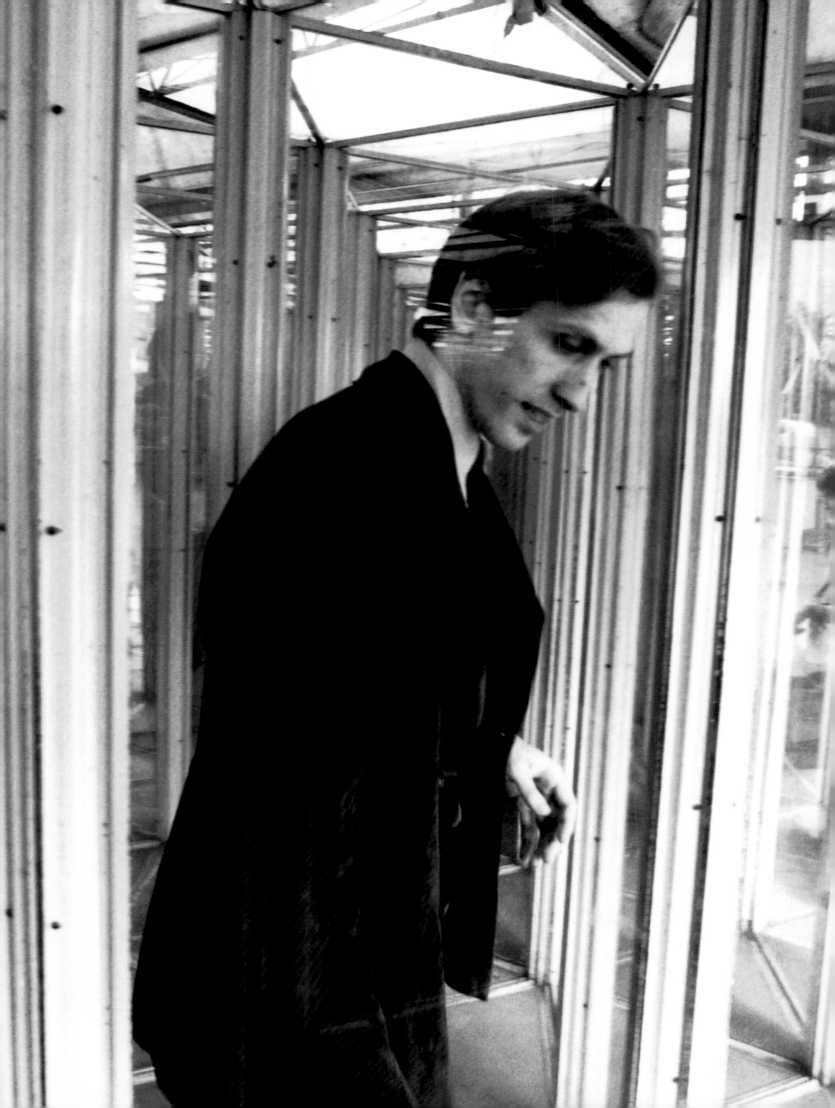

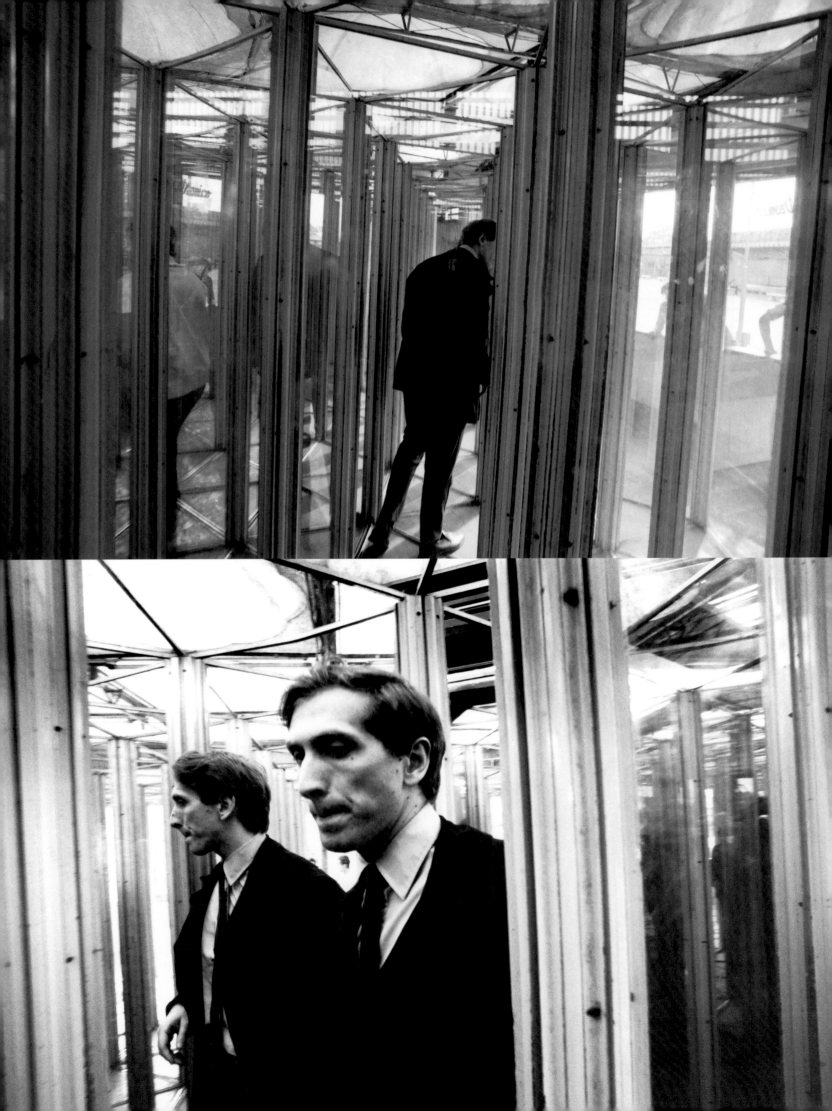

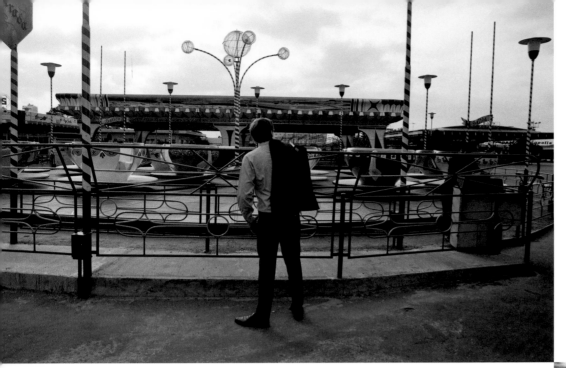

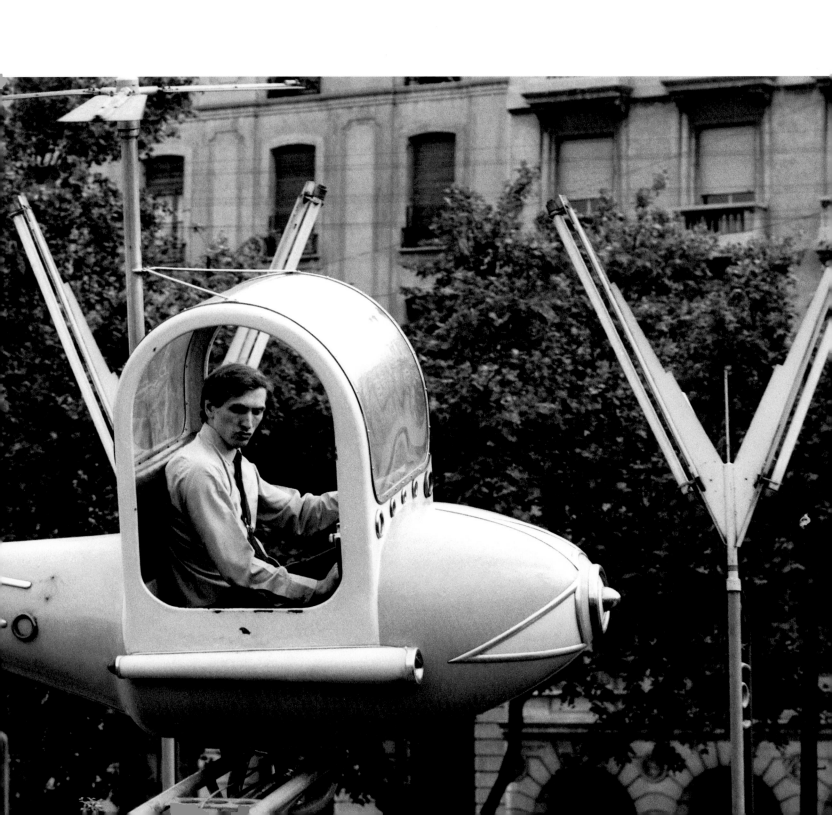

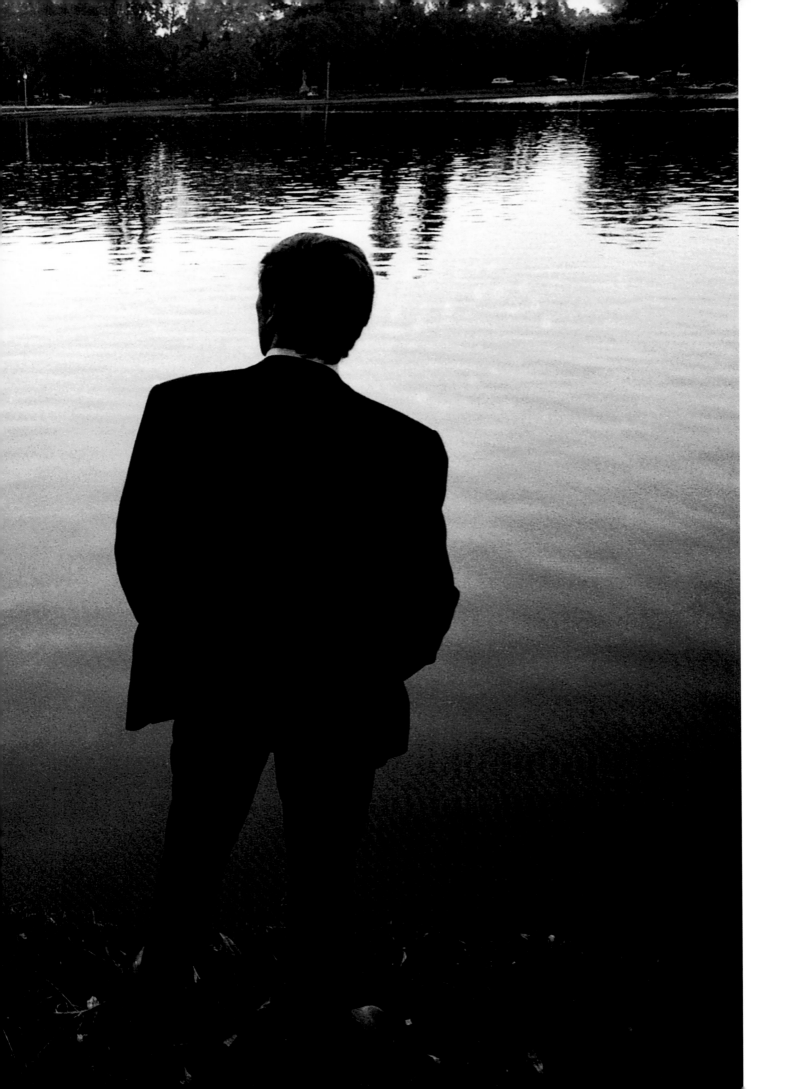

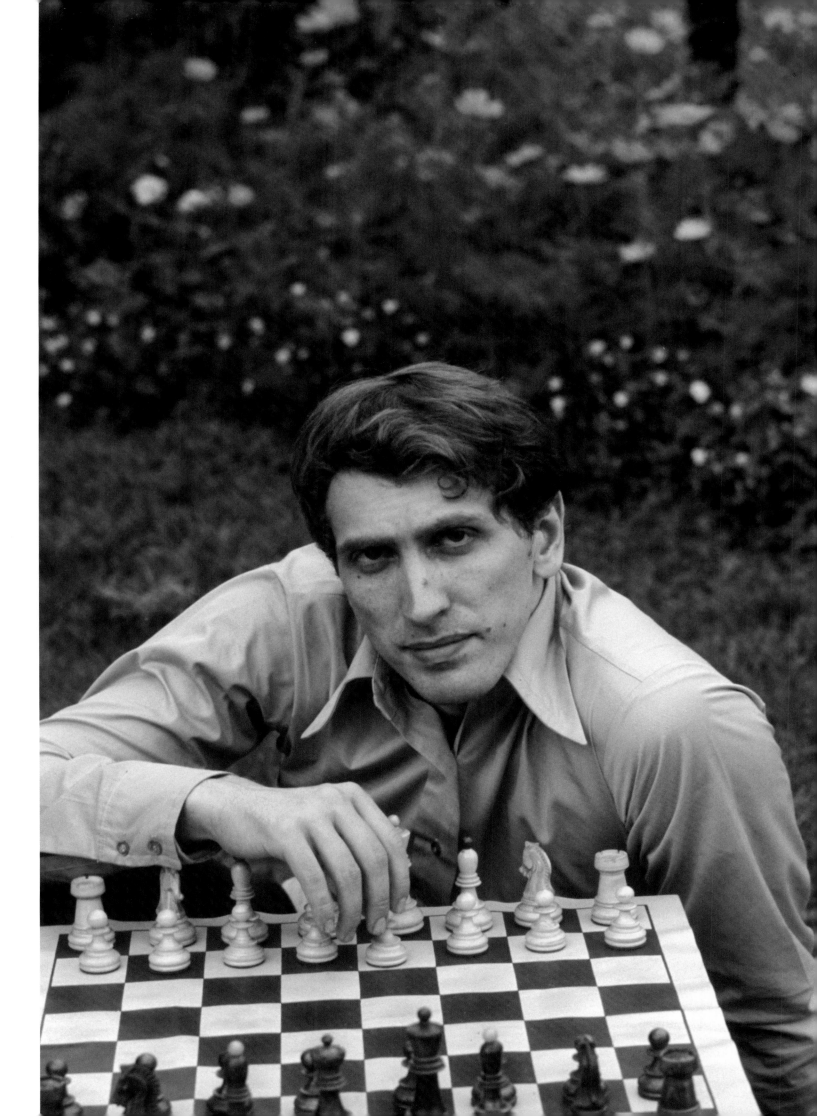

GROSSI

MAY 1972: Grossinger's was a huge resort complex in the Catskill Mountains near Liberty, New York. The family-oriented resort, steeped in New York history, was near enough for New Yorkers to visit for the weekend. Entertainers came from the Borscht Belt circuit; comedians and singers like Danny Kaye, Milton Berle, Eddie Cantor, and Eddie Fisher played to the New York-New Jersey, mainly Jewish, audience.

Bobby was well aware of Grossinger's history and knew it was where boxing legends Jersey Joe Walcott and Rocky Marciano and

baseball's Jackie Robinson had come to train. Bobby considered himself an athlete, and it made sense that he would want to train there. He told me that sitting for hours and hours concentrating on the chessboard required enormous stamina.

Bobby trained with a single-minded persistence and was determined Spassky would not wear him out at the table. He followed a strict regiment each day to prepare for the physical demands of the grueling match. First he would go for a run, have a big breakfast, and then a

NGER'S

rubdown. Next he worked out on the punching bag, the stationery bike, and would jump rope. Then a shower, rubdown, and sauna.

To build up lung power, he would swim laps and stay underwater as long as he could. A late afternoon tennis game ensued along with an occasional serious table-tennis match against a world-class player who happened to be at the resort at the time. Bobby would talk to me like a boxer in training—he had obviously seen newsreels of boxers being interviewed while they trained. He would say, "I've got to be fit. I've got to be strong. The

Russians are very aggressive, but they're not going to wear me down. Never." Bobby did have a strong body. He was tall and actually quite handsome with an infectious smile—when he smiled. When he was tired he could plop himself down and fall asleep for a few minutes as if on cue. He was like a child that way.

It was at Grossinger's that Bobby casually mentioned to me the date he would arrive in Iceland. Actually, he arrived only one day later despite all the hoopla surrounding his fleeing from JFK airport in New York to get away from a newspaper photographer

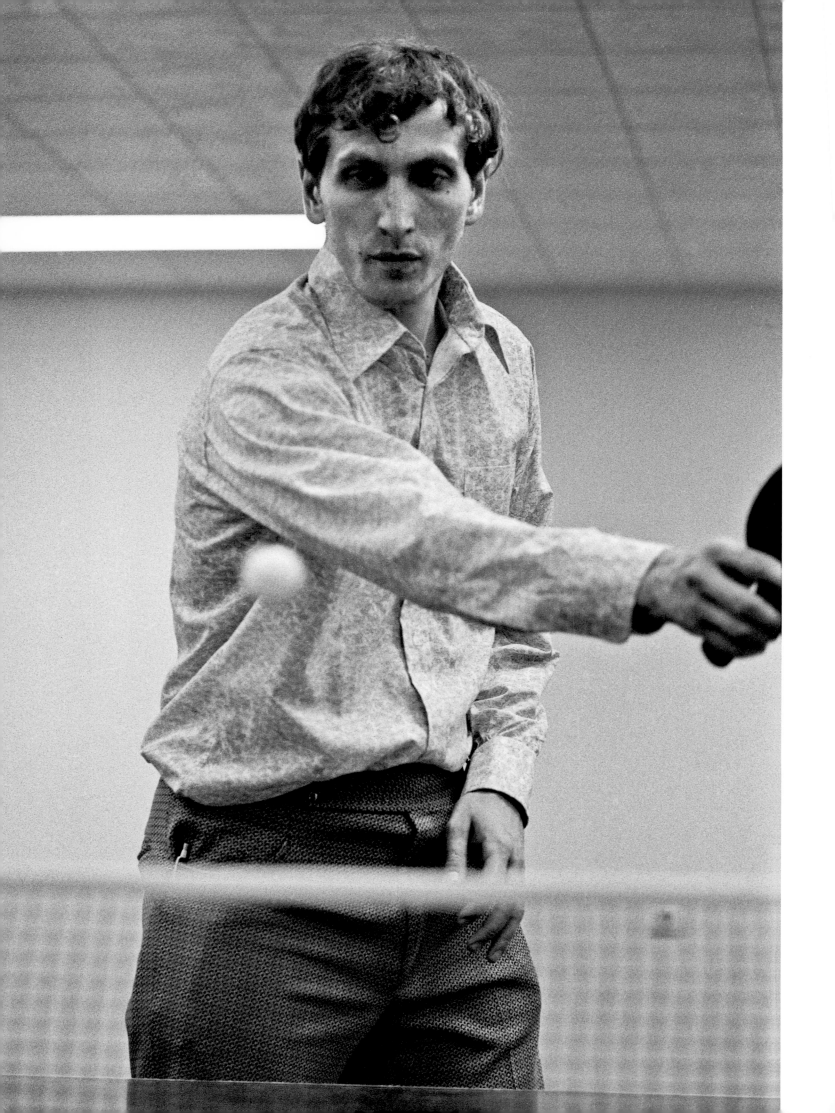

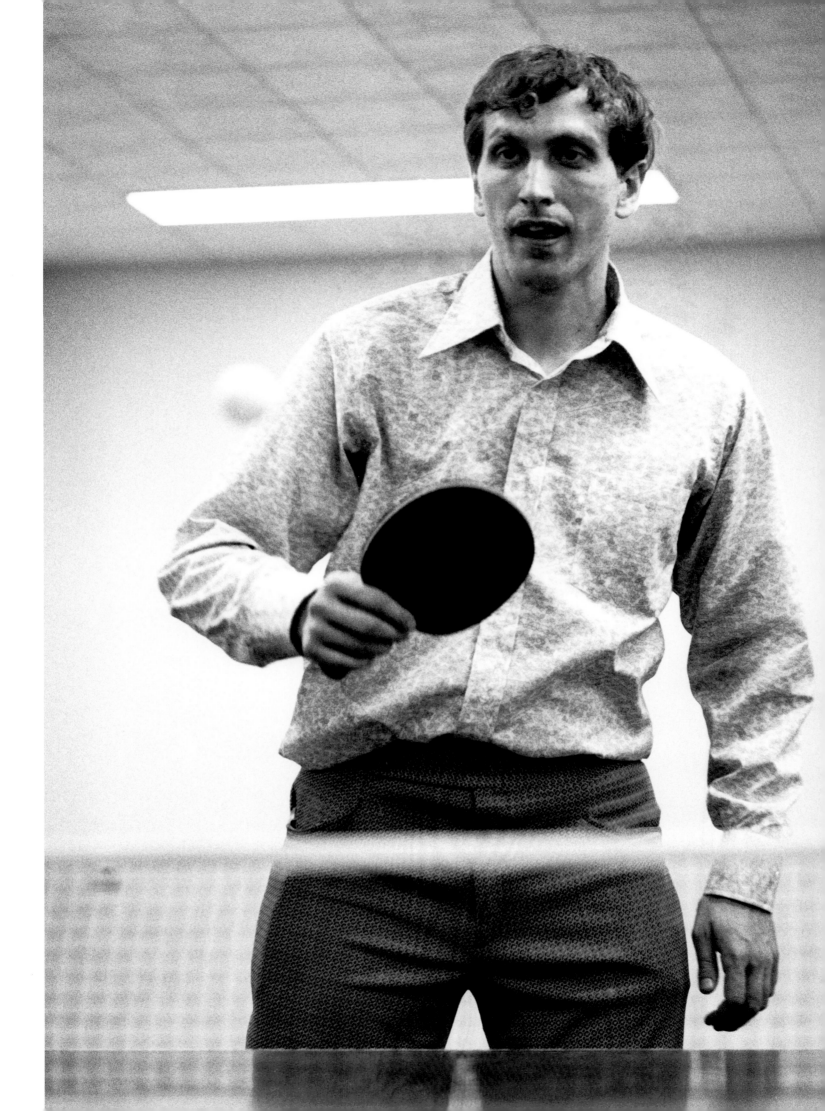

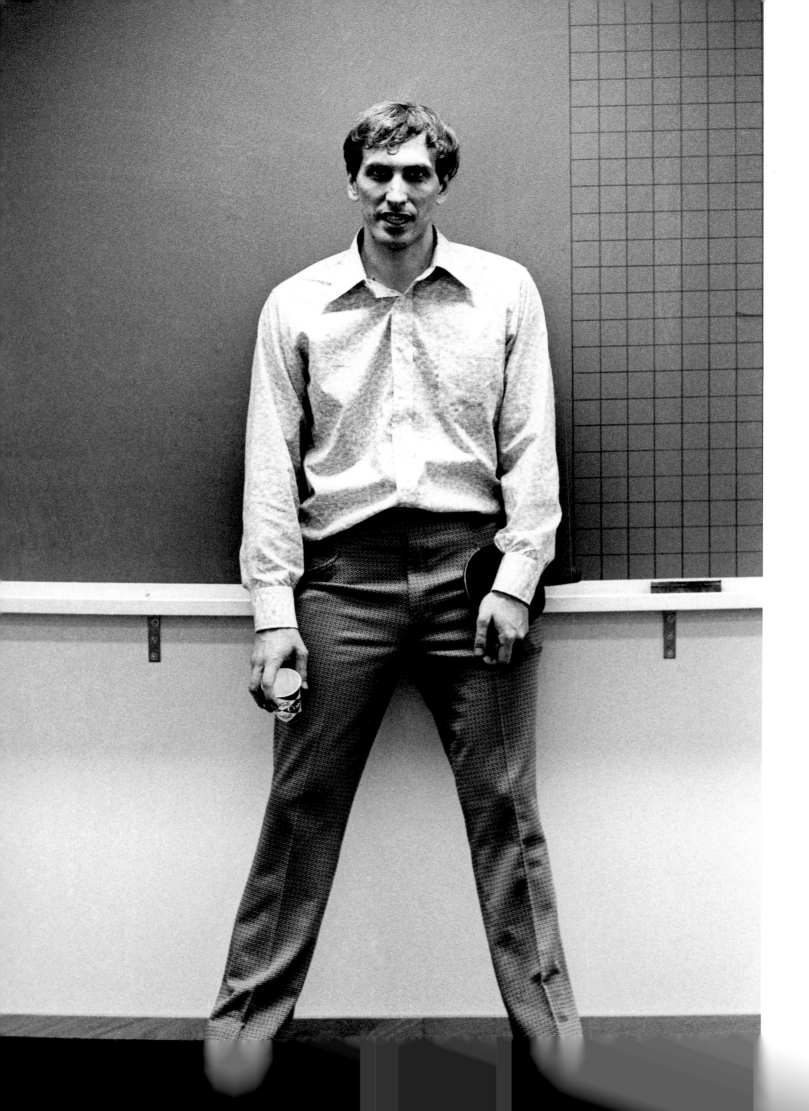

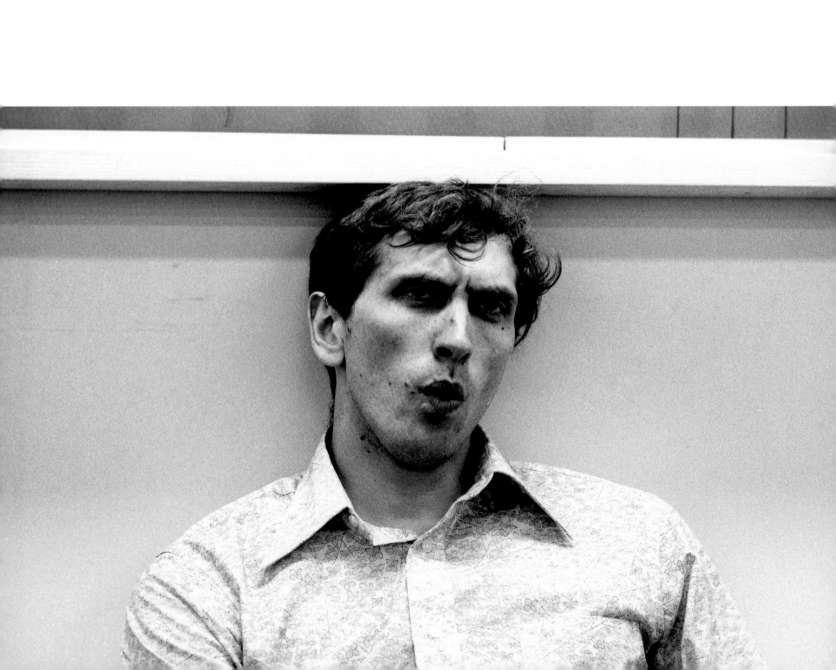

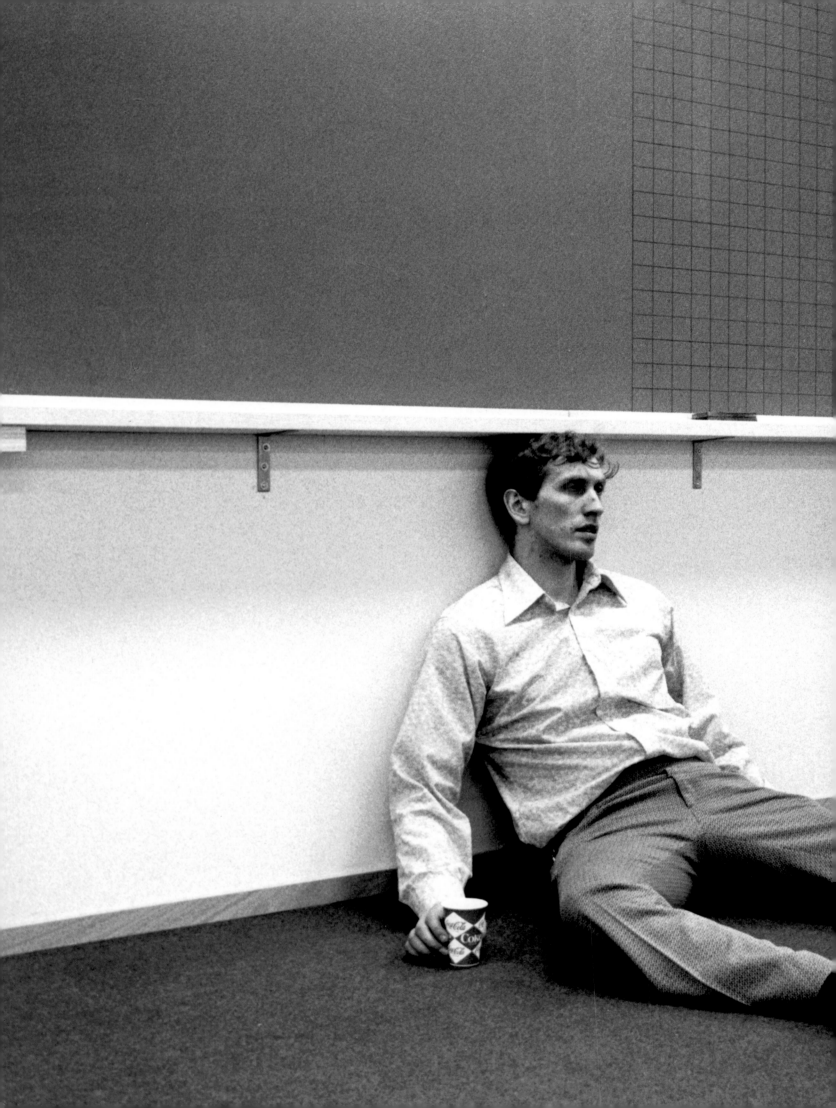

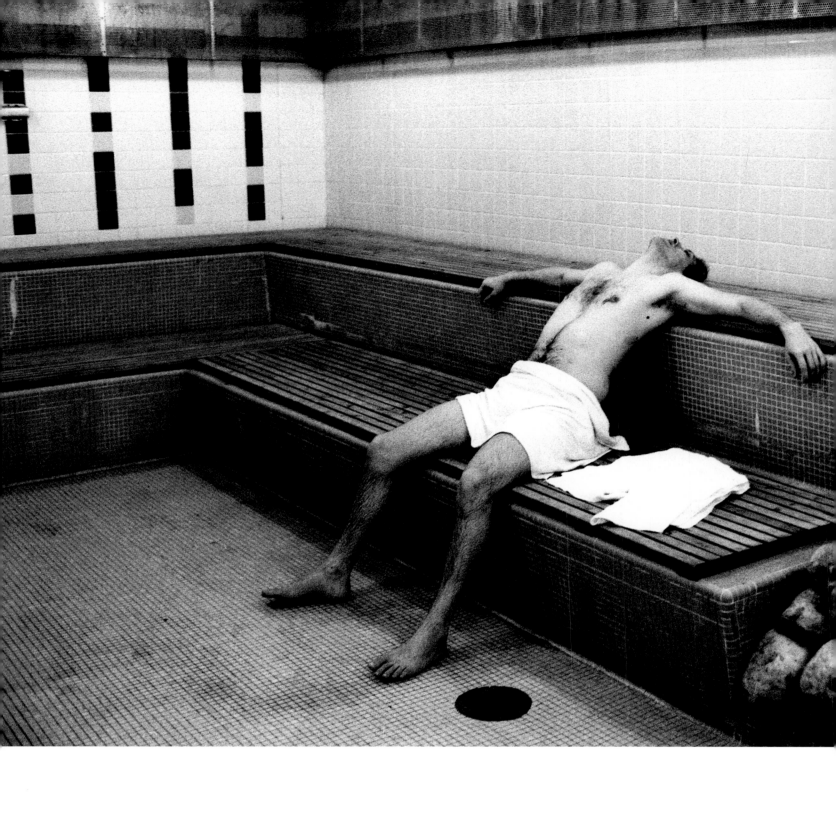

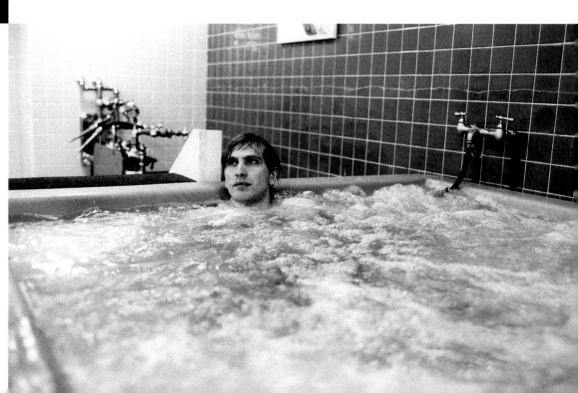

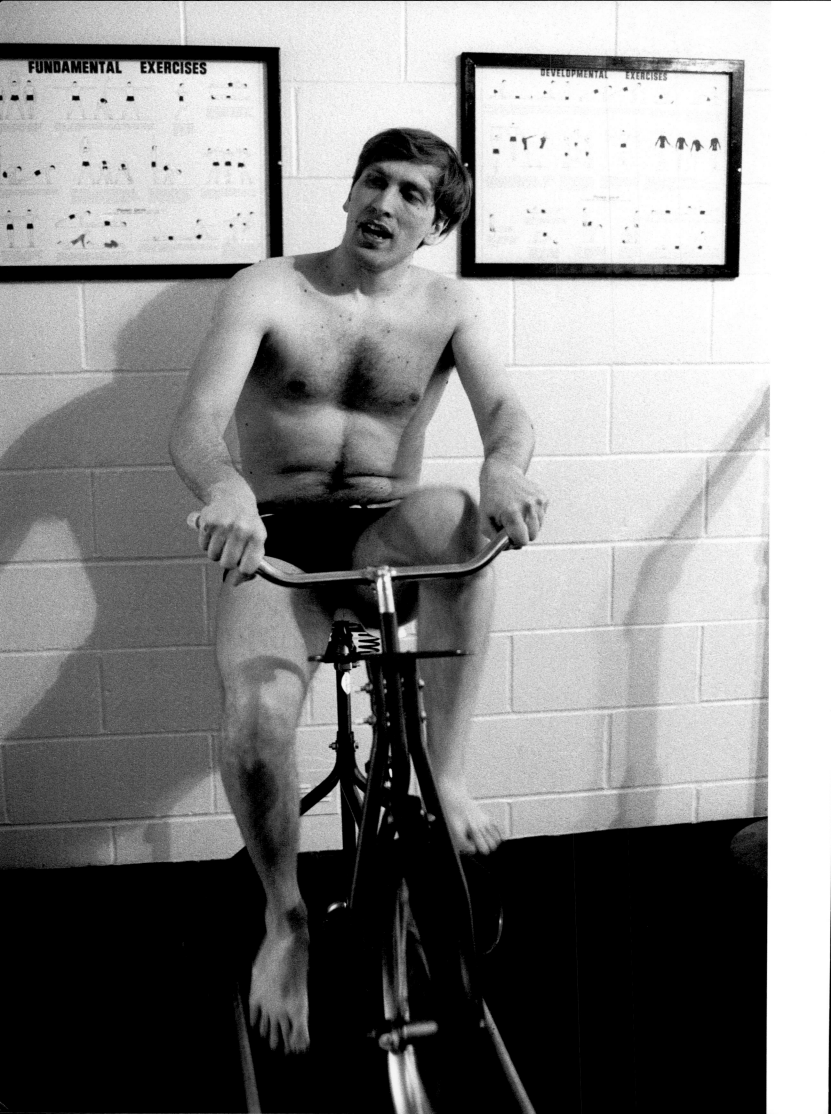

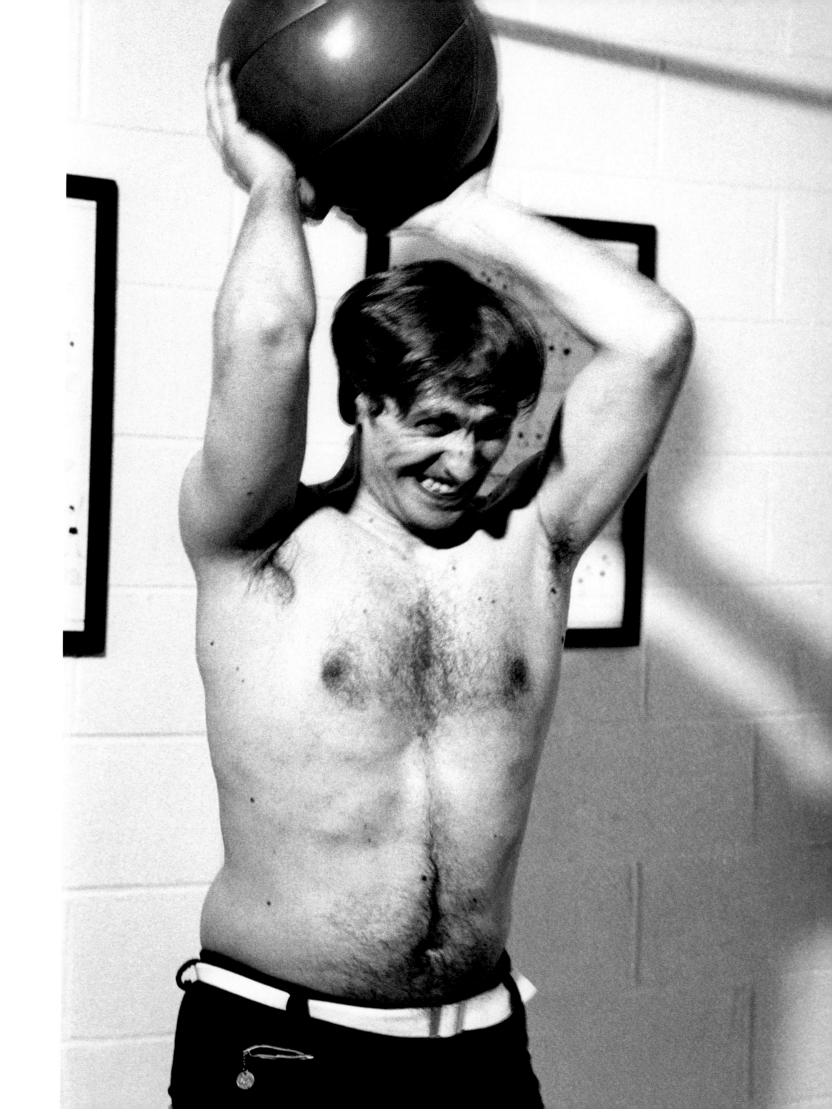

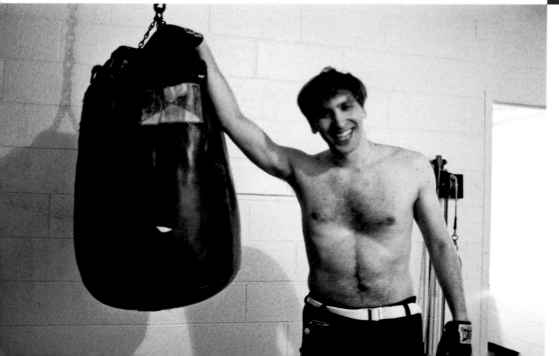

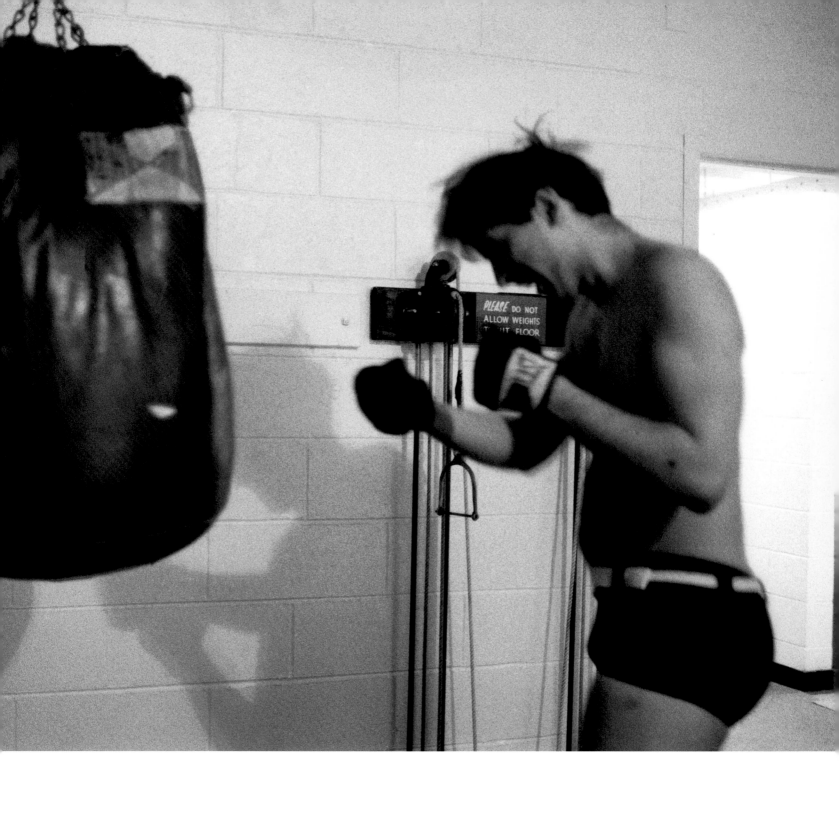

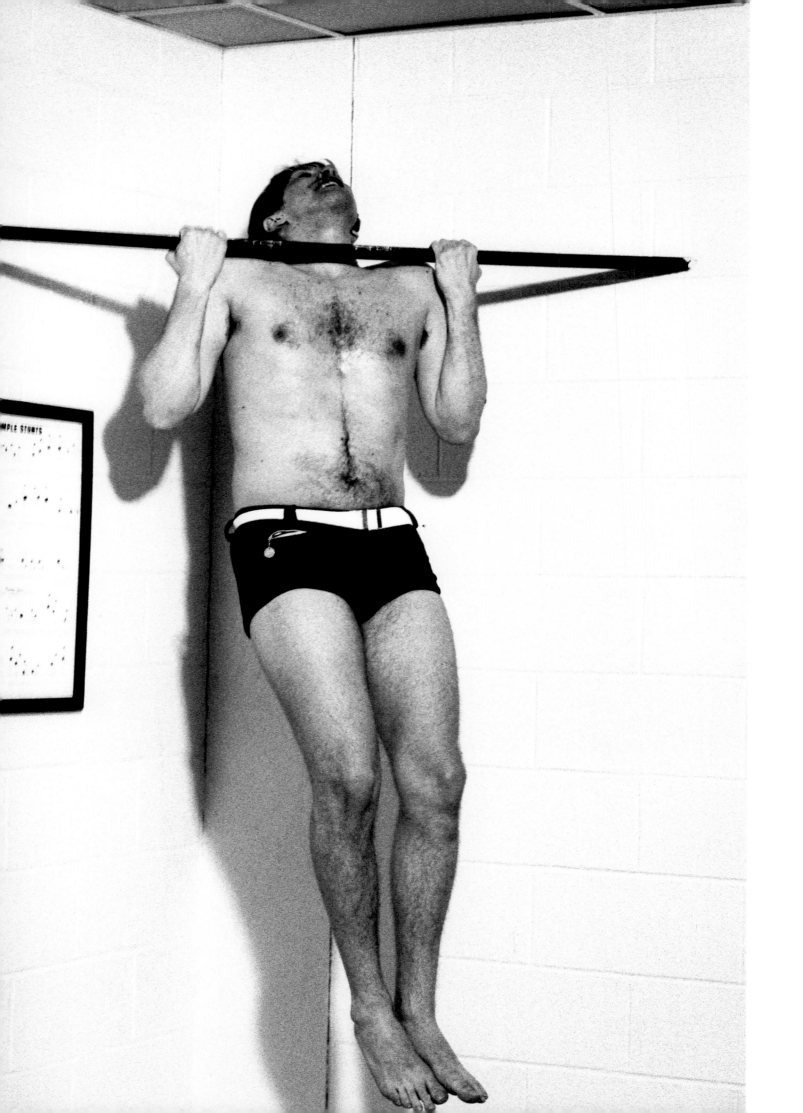

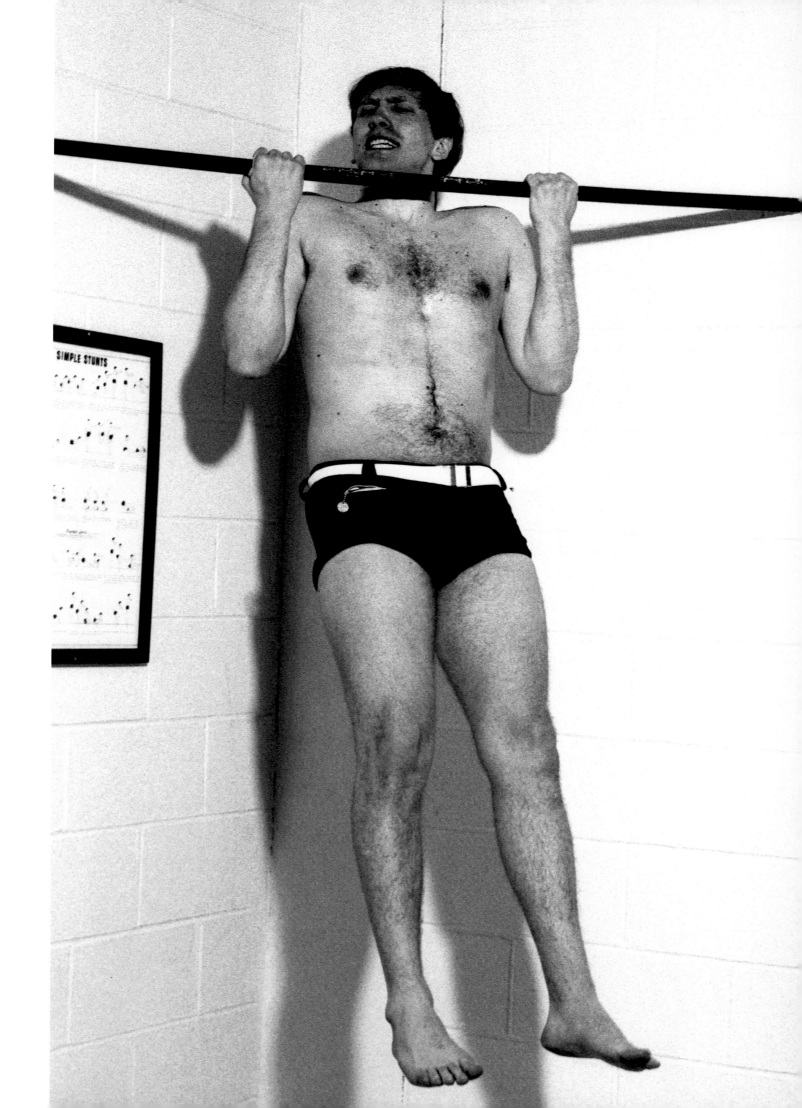

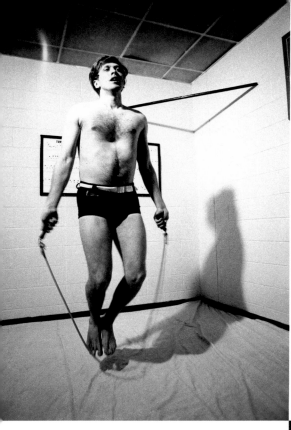
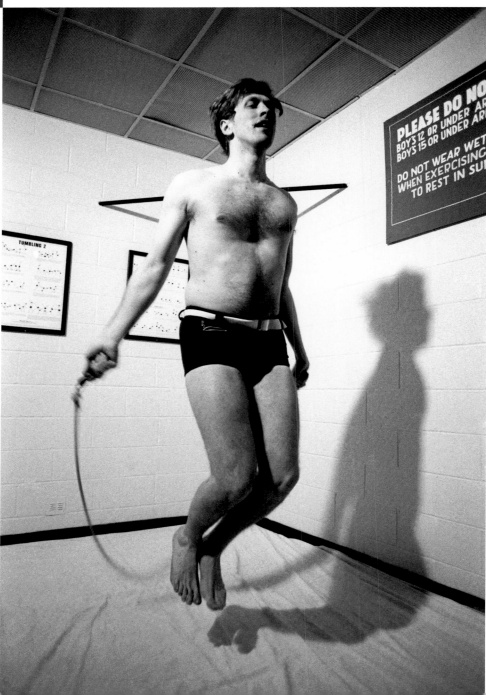

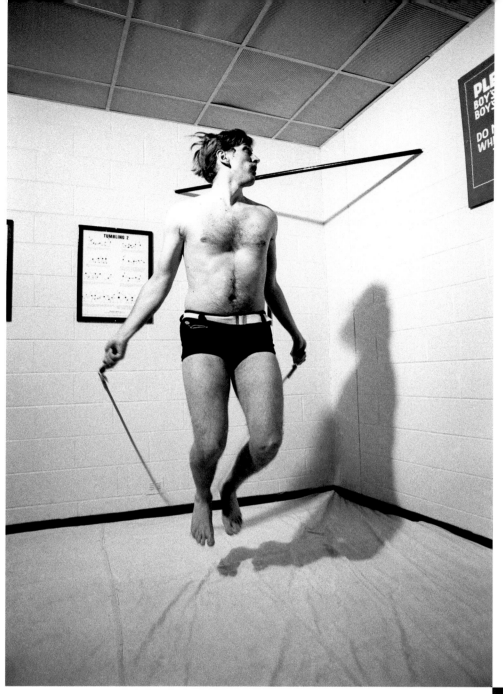
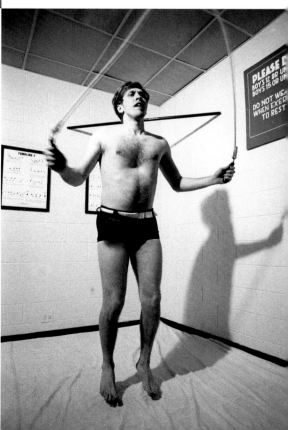

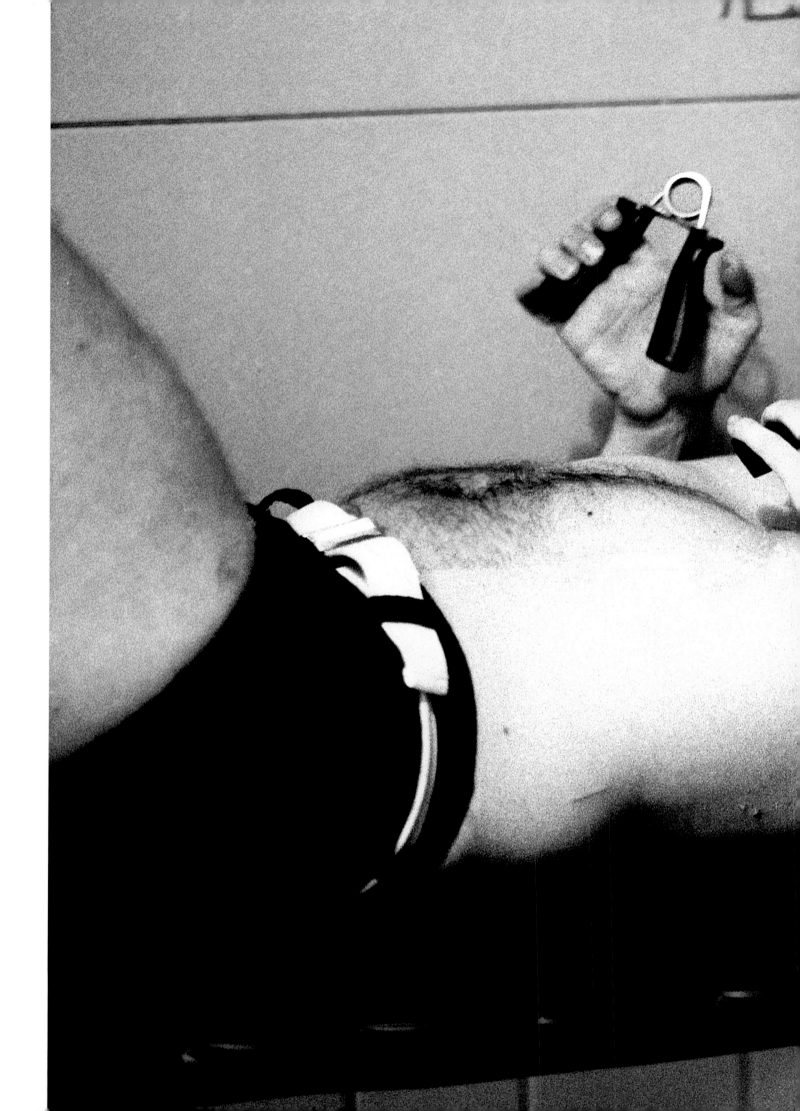

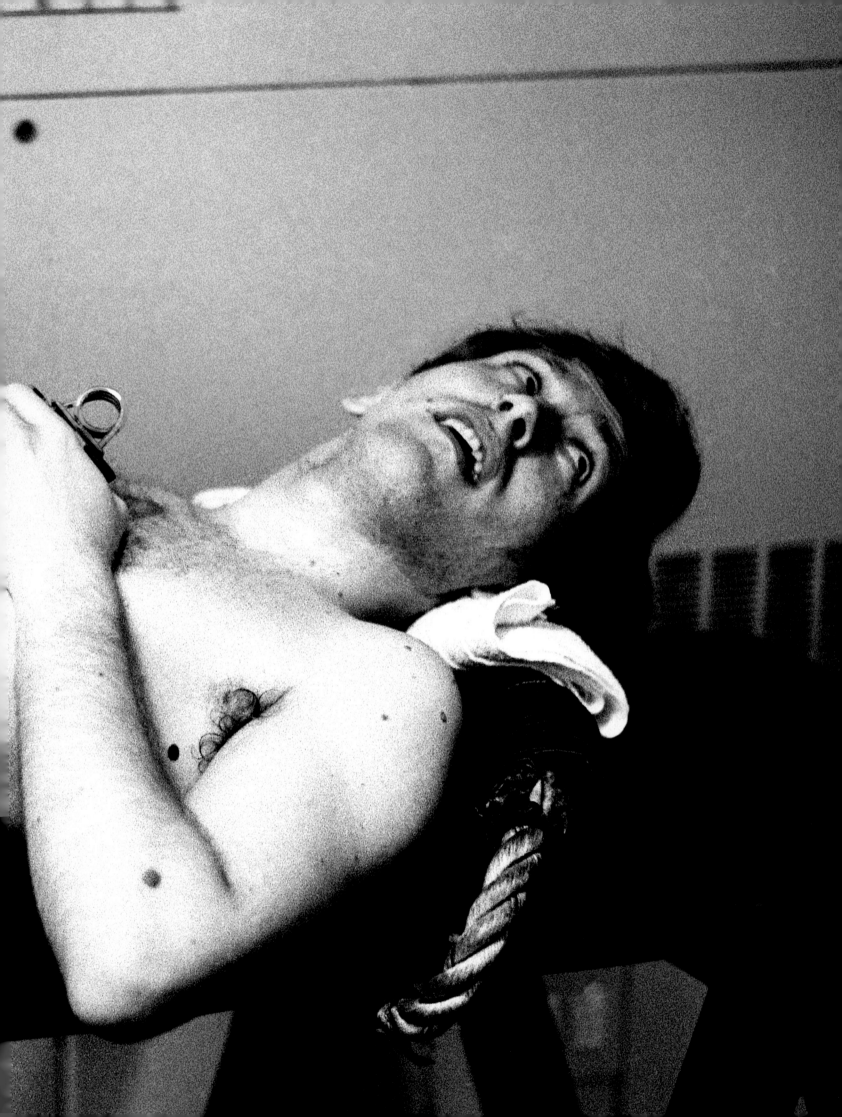

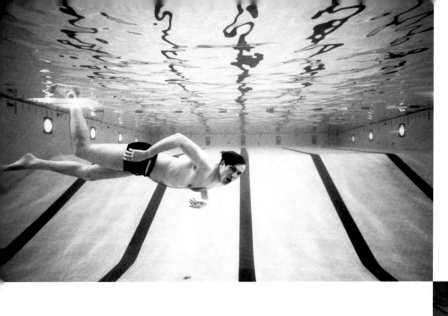

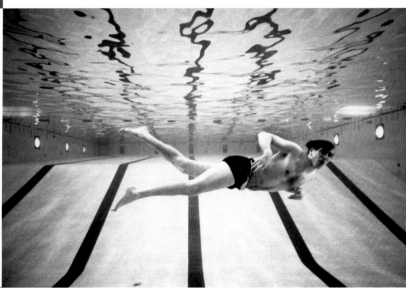

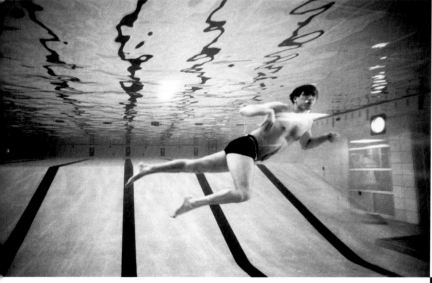

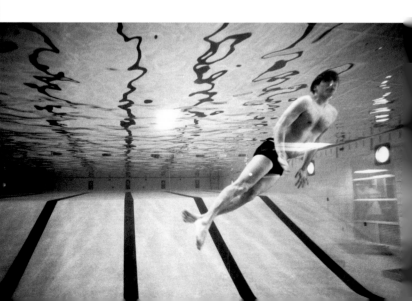

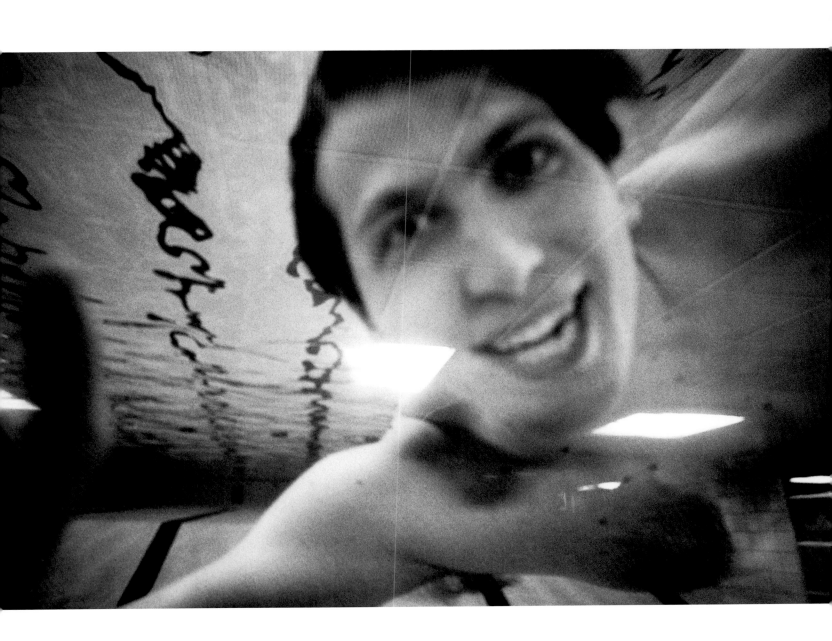

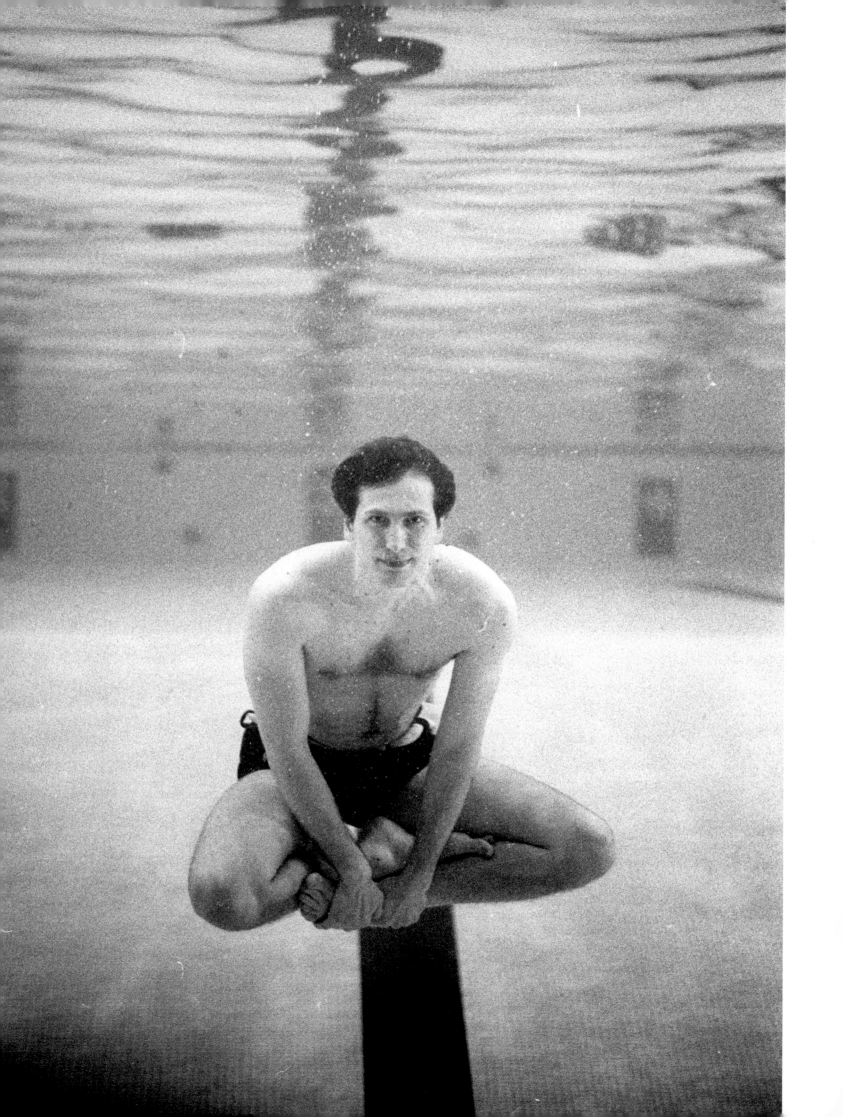

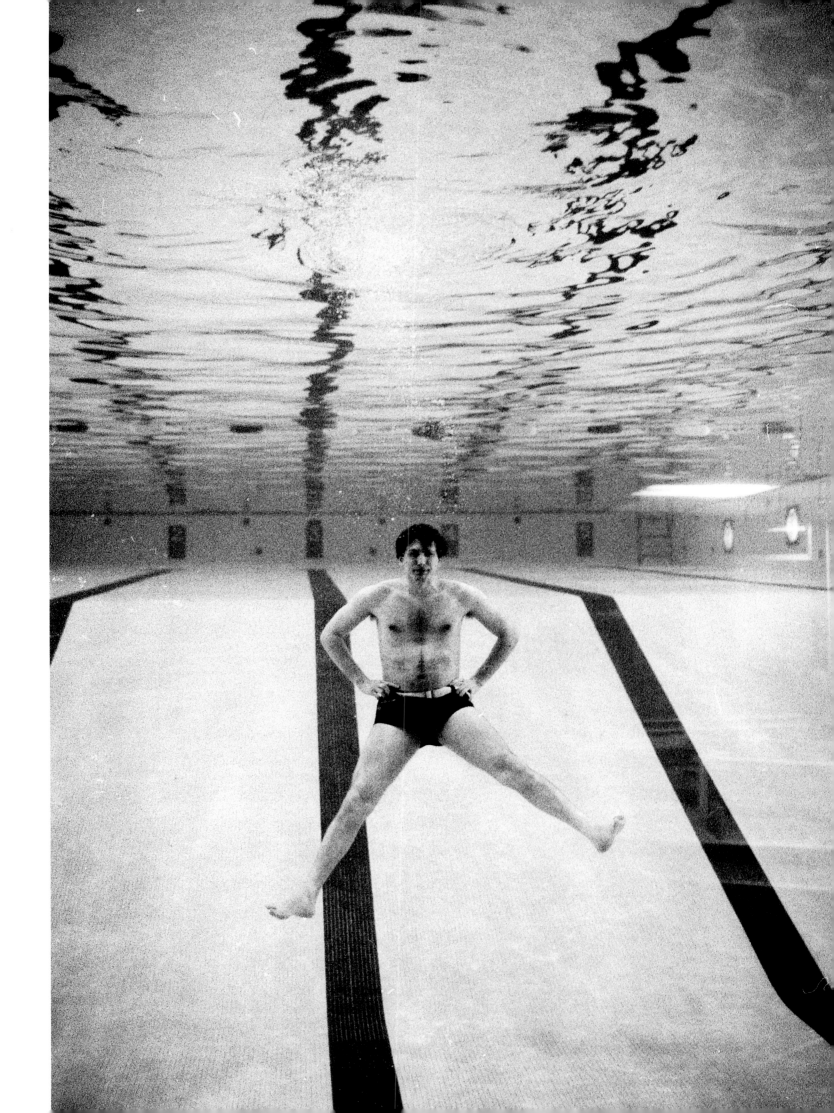

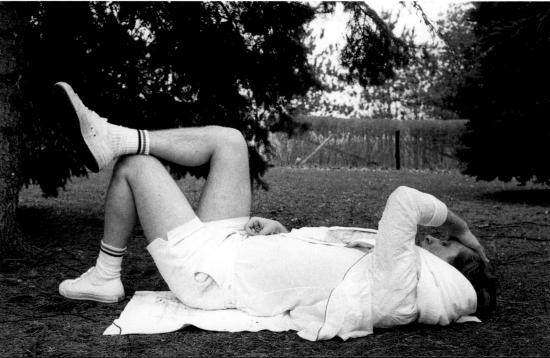

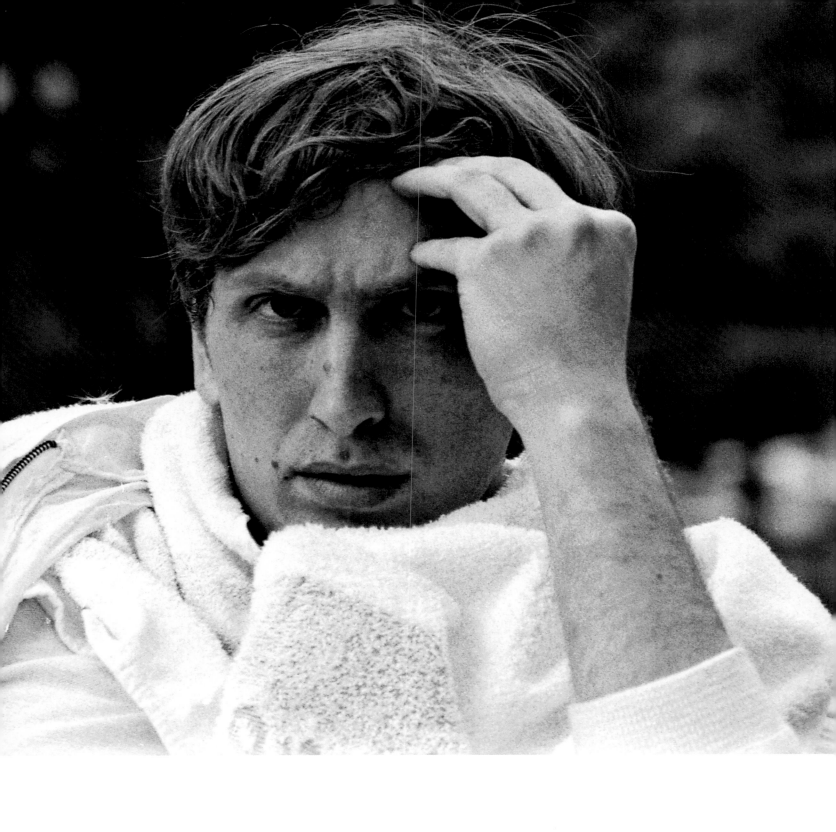

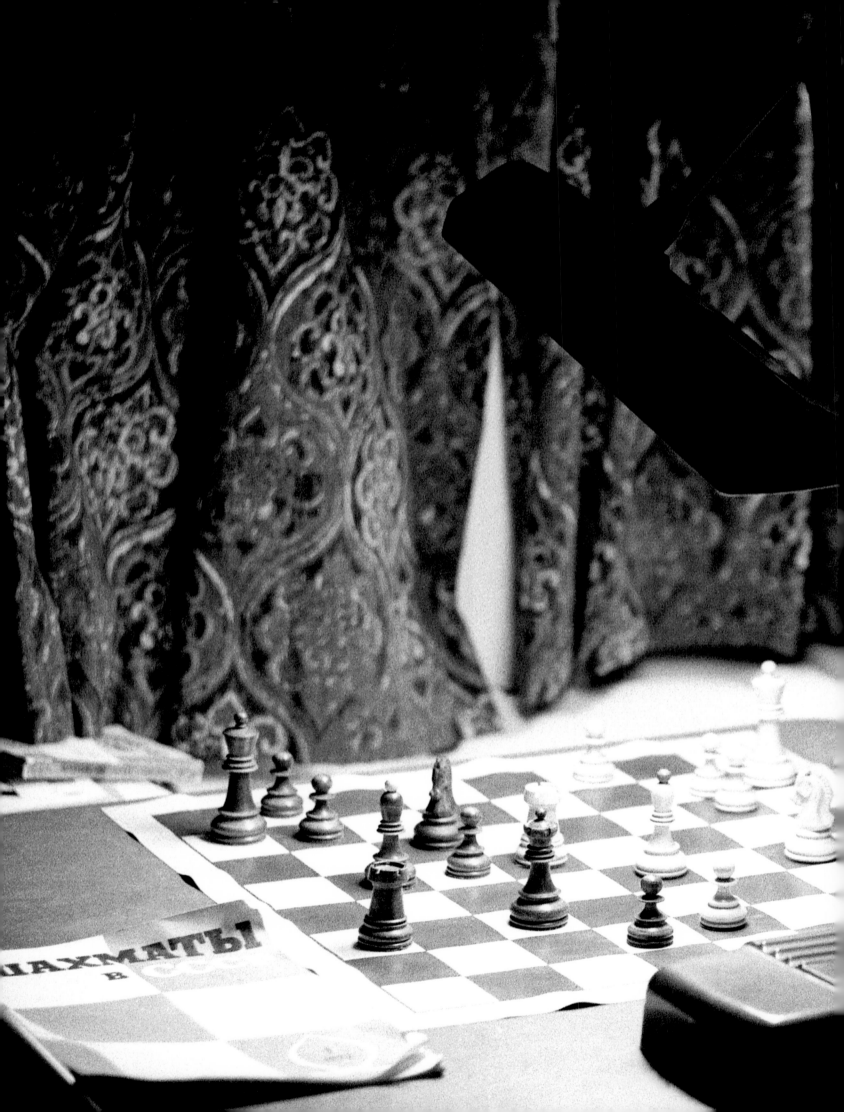

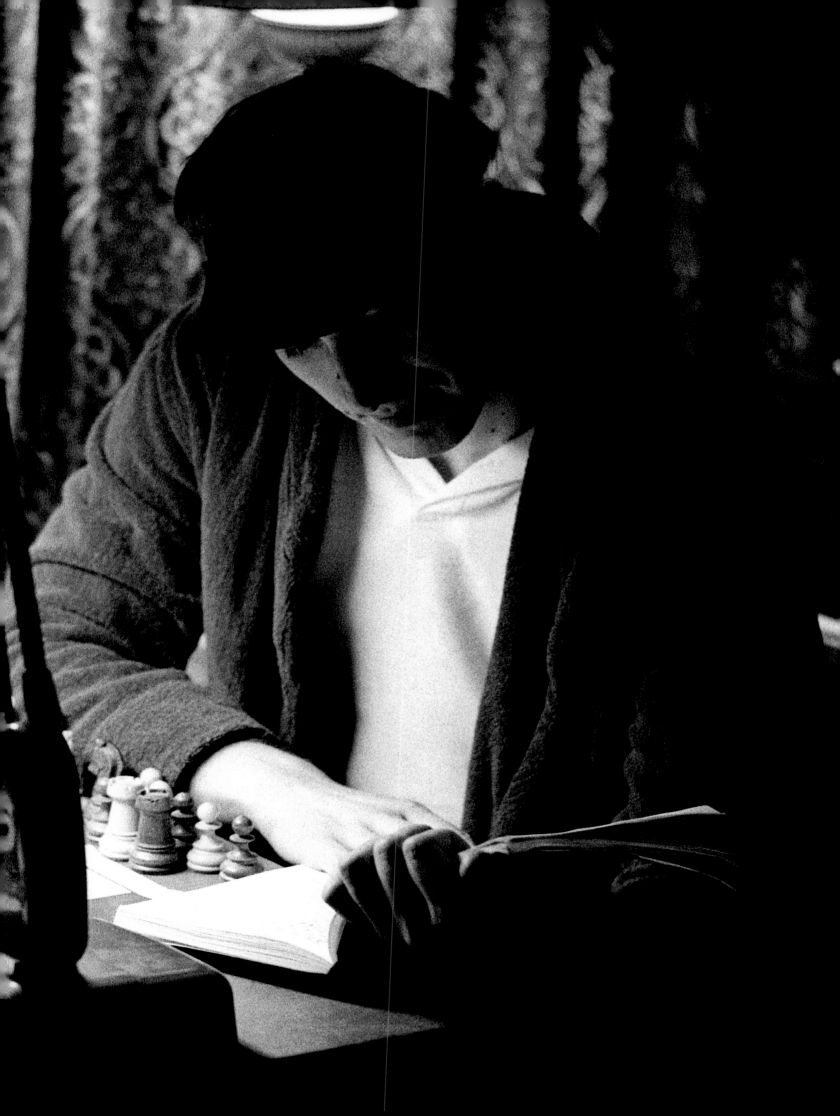

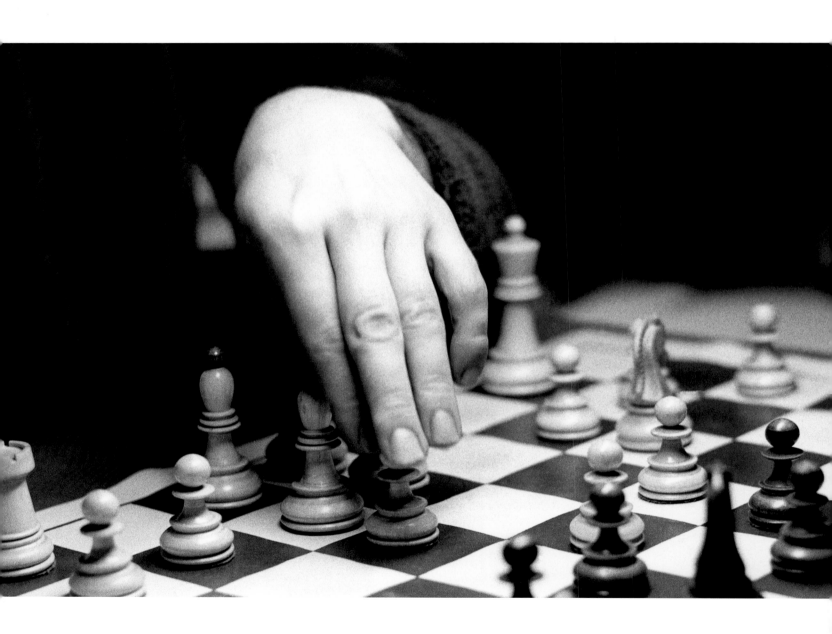

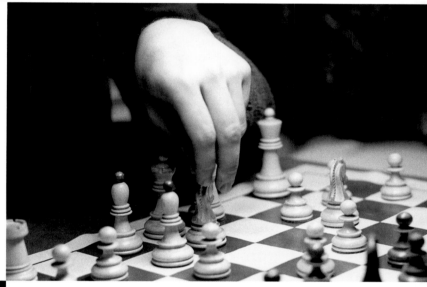

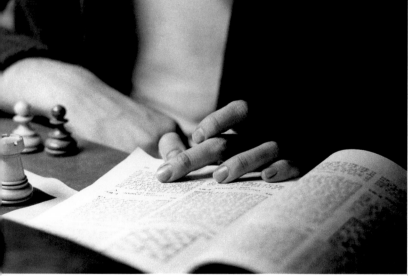

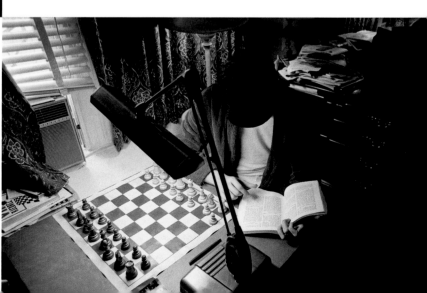

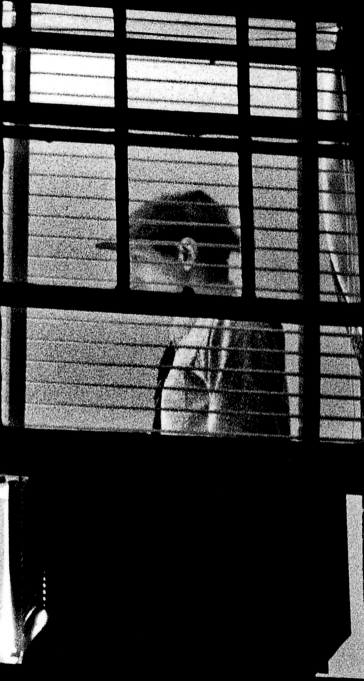

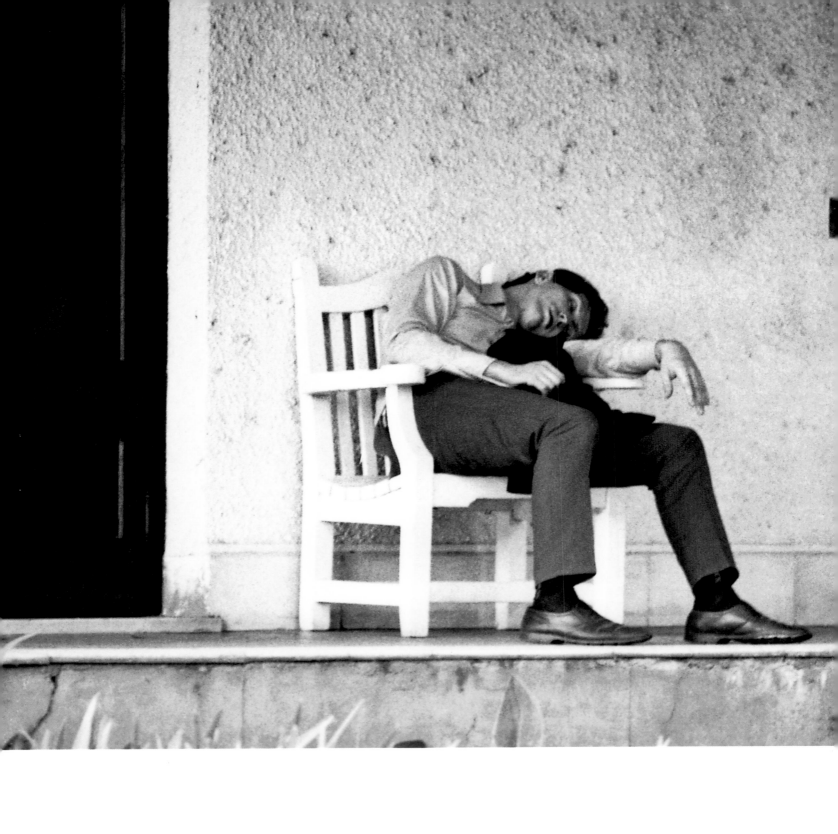

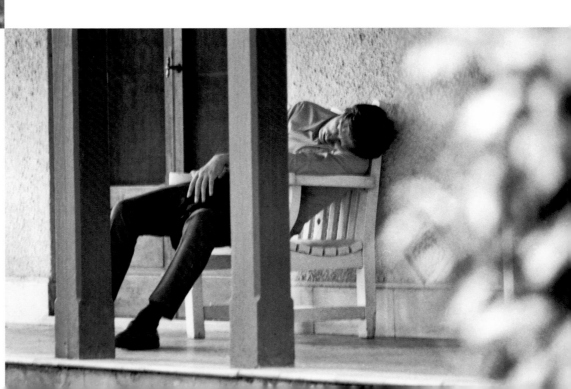

ICEL

JUNE–SEPTEMBER 1972: THE MATCH OF THE CENTURY

The World Chess Championship match between the American challenger, Bobby Fischer, and the reining Russian Champion, Boris Spassky, billed as the "Match of the Century," was to be held in the middle of the North Atlantic, in the unlikely city of Reykjavík, Iceland, and I was to be there to photograph it.

Boris Spassky arrived in Reykjavík with his team of grandmasters well before Bobby who kept postponing his arrival. Even though to the casual observer, Spassky was calm with a pleasant demeanor, it turned out none of his grandmasters liked him, if you can believe what they said behind his back. At the same time, Bobby was being indignant and causing a commotion with his demands —a certain chair, the height of the table—the negotiations went on and on, and still no Bobby. Everyone was guessing. Would the match take place amid the turmoil or would it be cancelled? Is it on or off? Yet Bobby

arrived only one day later than he told me he would when we were at Grossinger's. I surmised his last minute arrival was part of his plan to unnerve his opponent.

As I was in the middle of two other stories—one on President and Mrs. Richard Nixon in Washington, D.C., and one on Joe Namath and the New York Jets football team, both important stories—I wasn't too concerned about what was happening in Iceland. The bottom line was I would photograph the match if it took place and that was that.

Boris Spassky was lonely so the Russian government brought his wife, Larisa, over to Iceland for a visit. I photographed them together in their hotel room and when I asked Spassky about Fischer, he grimaced and made a funny face mimicking him that I caught on film. To pass the time while he waited for Fischer to arrive, Spassky attended the ballet and was delighted when I took him backstage to meet my friend, English prima ballerina Margot Fonteyn after her performance.

To get to Bobby at this stressful time was not easy, as the entire world press was calling the match a battle in the Cold War struggle between the U.S. and U.S.S.R. The pressure was enormous, and while Spassky was surrounded by his entourage Fischer was virtually kept at arms length from the American Embassy in Iceland. Bobby regarded the press as "enemies," yet there had to be one friendly face in the enemy camp, and I figured it might as well be me.

Bobby completely mesmerized Spassky from the first day. Bobby's strategic maneuvers including showing up late at the hall, and keeping Spassky waiting noticeably unnerved the Russian. To my mind it was all part of Bobby's master plan, not erratic behavior as some were calling it.

The first night Bobby knocked on my hotel door very late and announced, "Let's go for a walk." As the sun never set in Iceland and Bobby had a hard time sleeping at night, this scenario repeated itself over and over while we were there. Bobby knew I had a car. We would

drive a few miles outside Reykjavík to the lava fields and then walk for hours, sometimes talking, sometimes walking silently, until Bobby would break the silence to say what he had been thinking about. We would discuss politics, boxing, football, and I mean we had serious discussions. There was nothing like small talk with Bobby. Our talks would be in-depth. Fortunately I like sports and politics and knew a lot about them, so it was easy for me. We never discussed chess, for Bobby knew I was at a loss on that subject. At night on the deserted roads I gave Bobby some driving tips. He would say, "Good tip, Harry," and told me he would remember them.

Bobby kept the door to his hotel room locked at all times and often slept on the couch near his chessboard, rather than on the king size bed in his room. He covered the mirror on the living room wall with a blanket so as not to be distracted by the reflection. He was afraid that his phone was being tapped by the Russians, and in retrospect, it most likely was. I once saw Bobby merely nod to

his mother in passing as he walked through the lobby of the Loftleidir hotel. Perhaps they visited together later when I wasn't there, but I never saw it.

One of my favorite photographs from my time in Iceland was Bobby being nuzzled by a horse, taken during one of our long walks during the white nights. It was a completely natural, spontaneous photograph. We saw a small herd of wild horses in the distant field. Bobby sat down and stared at them. Slowly they came closer and closer and started to surround him. I was about 15 yards away when a beautiful white horse came right up to Bobby and nuzzled his cheek. Bobby marveled, "He likes me, Harry, he likes me." It happened on three or four different nights, but then the horses were gone, and we never saw them again.

A story like Fischer is a 24-hour-a-day job. It is constant. Another photo was taken around four a.m. Bobby, wrapped in a blanket, was sitting on the back of a boat in a chilly fjord near Reykjavík. To me this revealed the loneliness and isolation of the position he was in, which he must have been feeling as well.

Even though it was some distance away, Bobby could see the Saga Hotel from his room at the Loftleidir. Since I had been in Spassky's room at the Saga, I pointed out the window to Bobby. He often stood at his window looking across as if to see his opponent.

As *LIFE* was a weekly, Sean Callahan who was deputy director of photography at the time arranged to have Icelandic Airlines fly my film back to New York to make the weekly deadlines. As transmission in those days did not ensure the highest quality, an airplane was the fastest way to get the film back to the office.

Over coffee Brad and I would marvel at how unaware Bobby was of his lack of conventional manners—his standard answers were "yeah" or "huh," sometimes with a slight smile, while the words "please" and "thank you" never crossed his lips. He had been alone so much of his life, engrossed only in chess, that he was almost totally lacking in conventional social skills. He was

always pleasant to be with, had a good sense of humor, and I understood and accepted him the way he was. He dated a girl while he was in Iceland, and his idea of a date was to have her meet him at the bowling alley on the U.S. army base near Reykjavík.

The first game began on July 11. Twenty-one games were played. After the first few the intrigue subsided a bit and I flew to Washington to photograph President and Mrs. Nixon. I mentioned to them and to Dr. Henry Kissinger that I was photographing Fischer in Iceland. Both Nixon and Kissinger asked me to extend an invitation to Fischer to visit the president in Washington when the match concluded. I told Bobby when I returned to Iceland, and he mumbled something about being "too busy" to bother with that now. But when I told him about photographing the Jets' famed quarterback Joe Namath, Bobby looked up with interest and was eager to hear all about that trip.

One afternoon around four o'clock, after the day's game was adjourned, there was a knock on my door. I opened it and no one was there. Looking down the hall I saw Bobby walking away. He shouted over his shoulder, "Harry, I'm going back to New York." I raced to his room where he was packing to leave immediately. *LIFE* writer Brad Darrach knocked on the door and came in. After a few minutes we were joined by a few people from the Chess Federation who kept pleading with Bobby to reconsider and change his mind. It turned out Bobby had booked himself on a flight back to New York. All Bobby would say was, "It was unprofessional." I knew enough not to ask questions, but I think it had something to do with Bobby feeling that he was not being given the respect he deserved from either the Russians or the American Embassy in Iceland.

There was a car waiting outside the Loftleidir. Brad and someone else knew which car and driver Bobby was using. They eased out of the room and went downstairs and from what Brad told me later, they opened the hood of the car and tampered with the spark plugs

and did something that would keep the car from starting. The uproar about the car lasted for about an hour and then as quickly as it had all begun, it stopped. All of a sudden Bobby looked at me and said, "Let's go to the bowling alley at the U.S. base near the airport." After we went bowling we went back to the hotel and had an early dinner.

At about midnight Bobby knocked on my door for our usual walk. He didn't say anything more about leaving, and I didn't ask. It was never mentioned again. Bobby just had to see something or hear something he didn't like and that was enough to upset him. It could last forever or it could last about ten seconds before he would do an about-face. As I've said before, Bobby was a complicated man. There were rumblings all throughout the tournament about his leaving, but this was the only time he had come close.

On the morning of September 1, I was to photograph Boris Spassky early in the day before he went to the hall to continue the previous day's 21st game. When I arrived at the Saga Hotel, Spassky was walking through the lobby. As I approached him, he stopped and said to me, "There is a new World Champion: Robert James Fischer." Then he said he was going for a walk and left. I immediately went to the Loftleidir hotel, went to Bobby's room, and gave him the news. He was surprised and a bit suspicious because he told me Spassky was in a bad position in the game but not an impossible one. Bobby was wary and thought the Russians might be playing a trick on him. He sat down at the chessboard in his bedroom, which was positioned as the game had finished the day before and said, without looking at me, "Harry, I'm in a better position, but Spassky's position isn't completely lost. I can see moves he could make to get a draw." Bobby then said he had to get to the hall to hear the announcement. Outside the exhibition hall, I ran into Harold Schonberg, a nice gentleman who wrote about chess for *The New York Times*, and I told him the news. The next day (September 2, 1972), my being the first to tell Bobby he was the champion made it into the front page story in *The New York Times*, although I didn't telephone him with the news as the *Times* reported.

Back in Bobby's room I photographed him with the ceremonial wreath and the winner's check for $78,125, his share of the $125,000 purse raised by the Icelandic Chess Federation. The next day we went back to the open lava fields where we had spent so many hours. I wanted a photograph with the headline "Bobby's The Champ," to document that historic day.

After Bobby returned to California, to the religious group where he lived, he used to telephone me at all hours of the night. The phone would ring and my wife Gigi would answer to the familiar, "This is Bobby Fischer, Harry Benson's friend." Gigi would sleepily hand me the phone and Bobby and I would have one of our long, middle-of-the-night conversations. Bobby and I had dinner once or twice when I was in Los Angeles. He liked the drinks adorned with umbrellas when I took him to Trader Vic's in Beverly Hills.

For twenty years after his win in Iceland, Bobby never played a match in public. But in November 1992, I flew to Yugoslavia where Bobby was to play Spassky once again. Bobby demanded an enormous amount of money to pose for *LIFE* magazine, so we just nodded to each other and I left.

That the U.S. revoked his passport and declared him a criminal for playing chess in Yugoslavia is to my mind a big part of the reason he reacted the way he did in his later years.

The news that he had died in January 2008, saddened me. He was an amazing chess prodigy and the most extraordinarily complicated and fascinating person I have ever met. And I feel privileged to have been one of the few he chose to let into his life.

Although controversy surrounds his later years, to me the real Bobby Fischer was the genius who single-handedly won a superlative battle for America against the Russians in the middle of the Cold War.

That to me is his legacy.

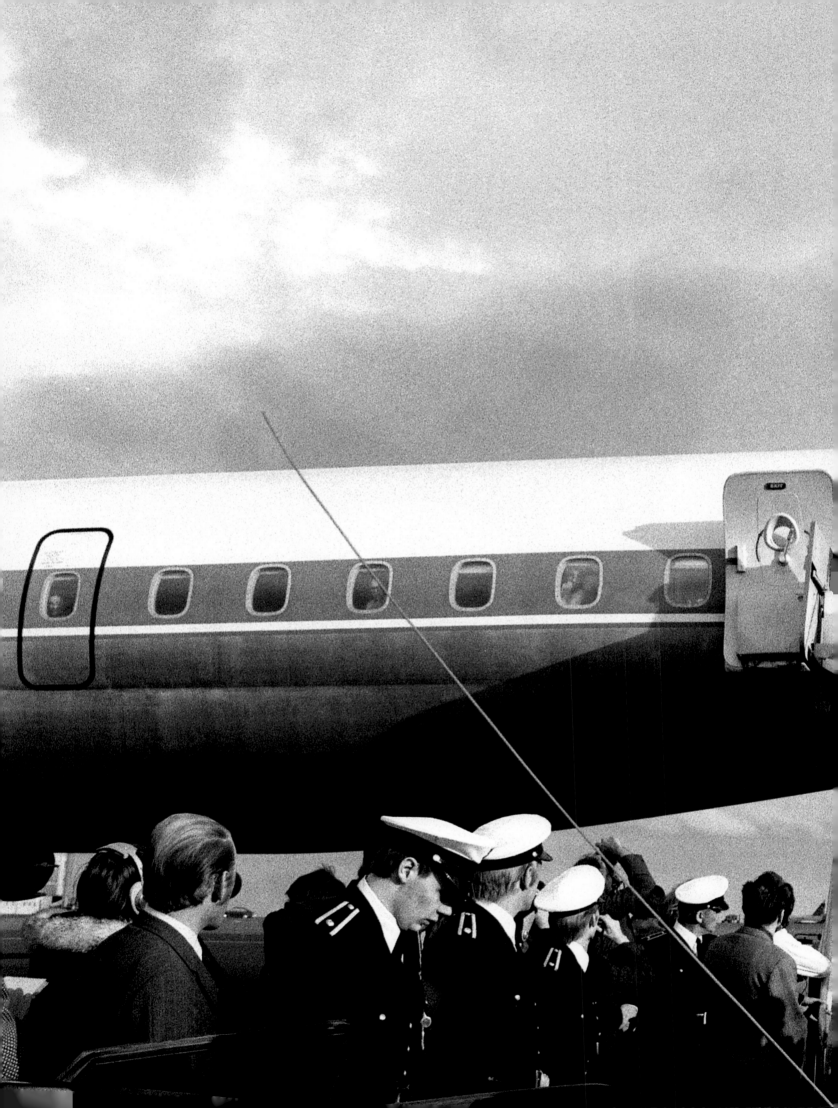

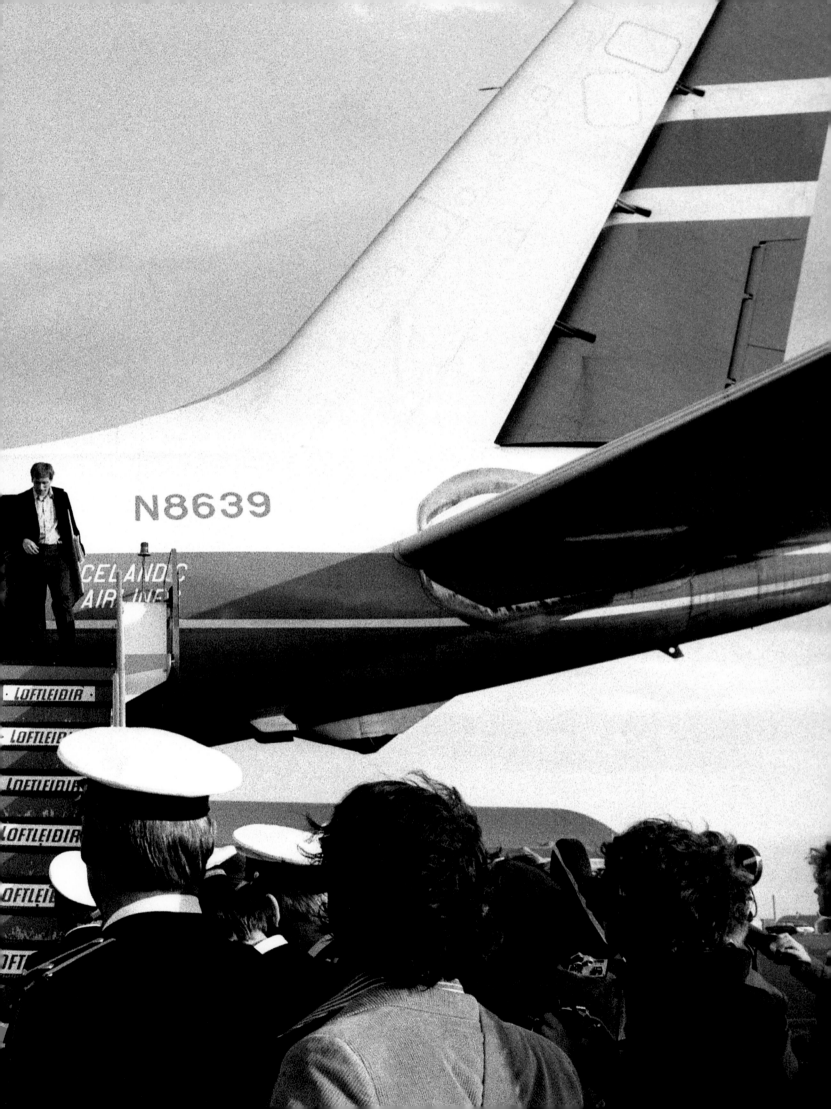

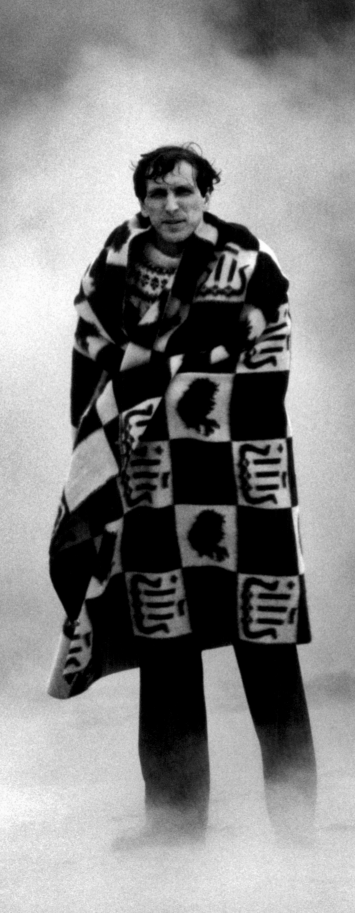

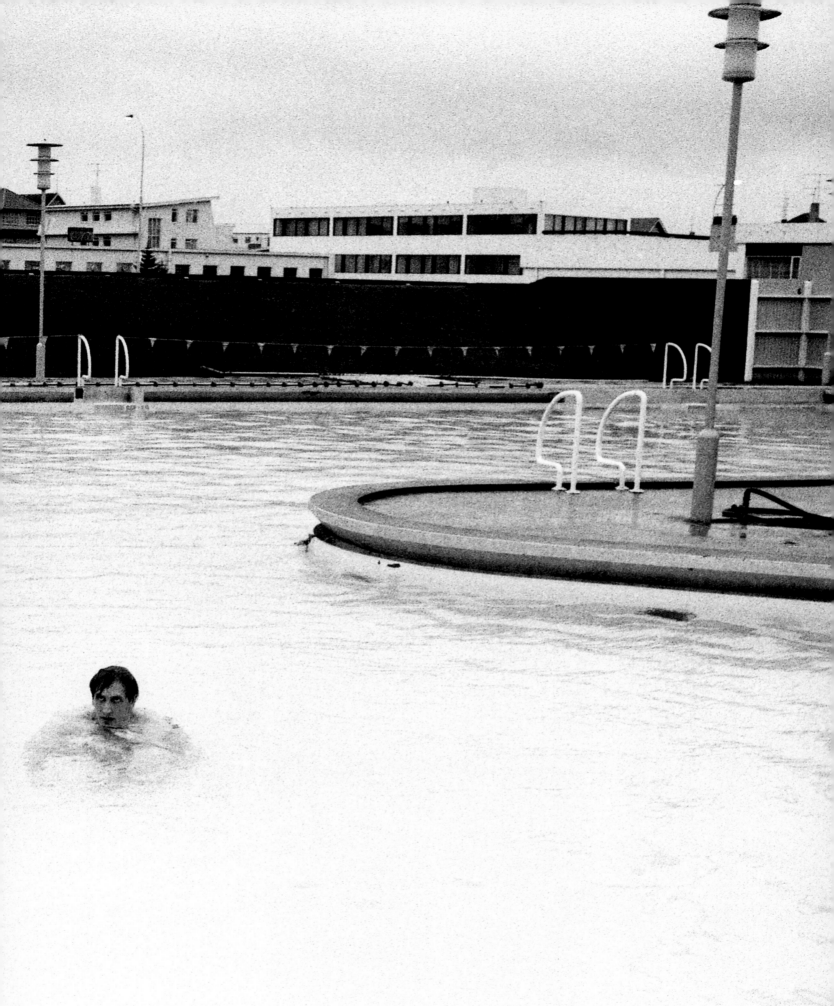

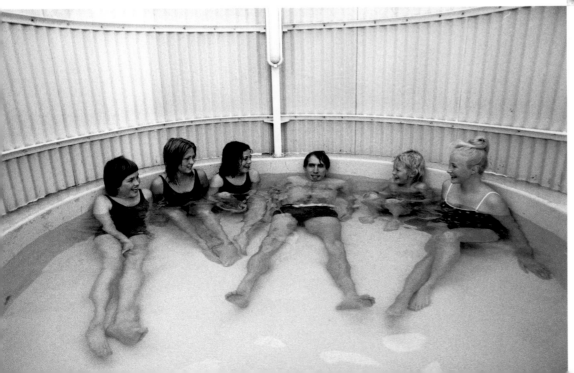

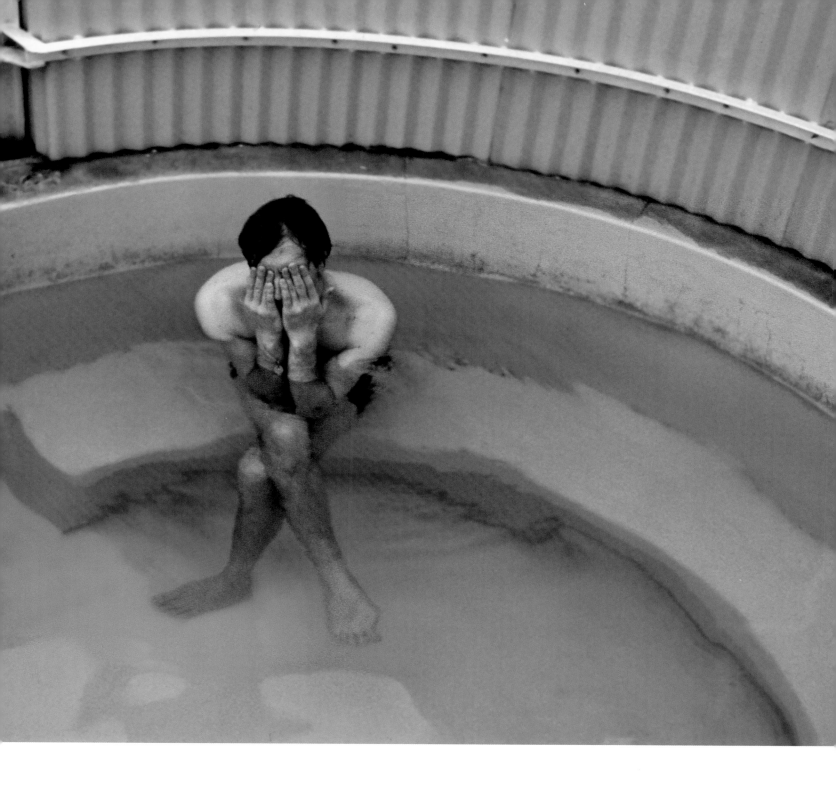

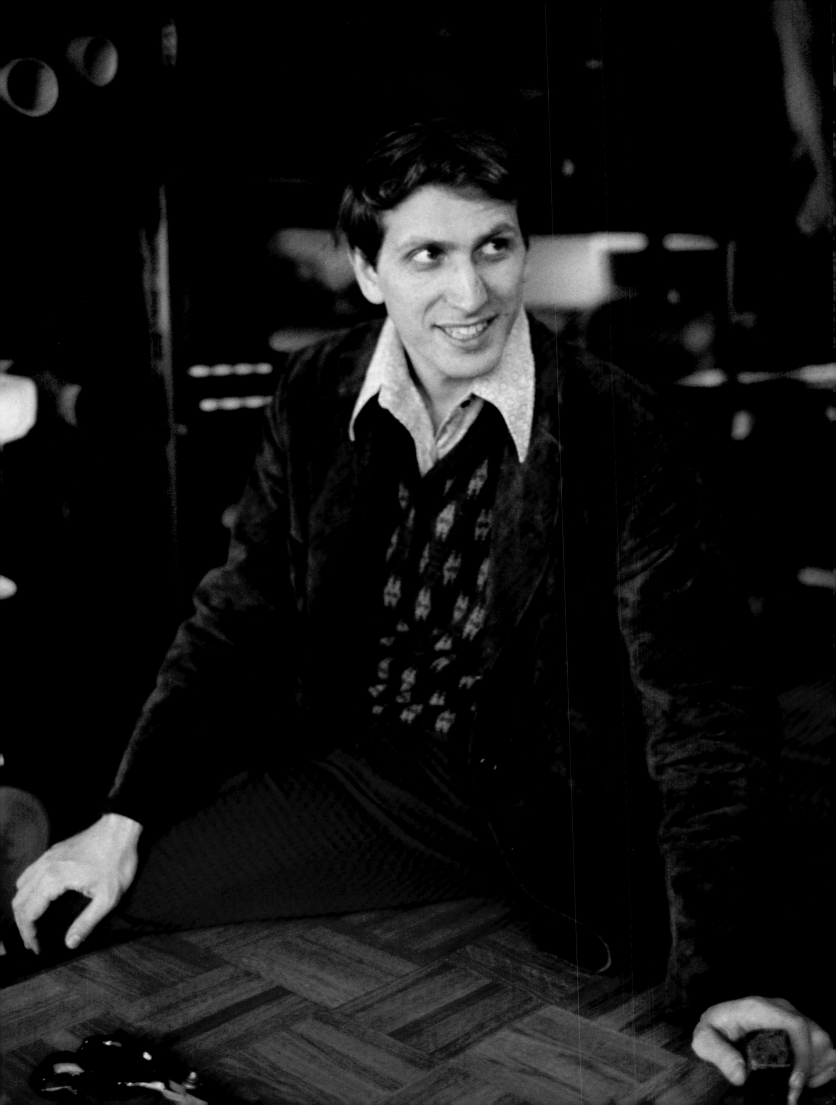

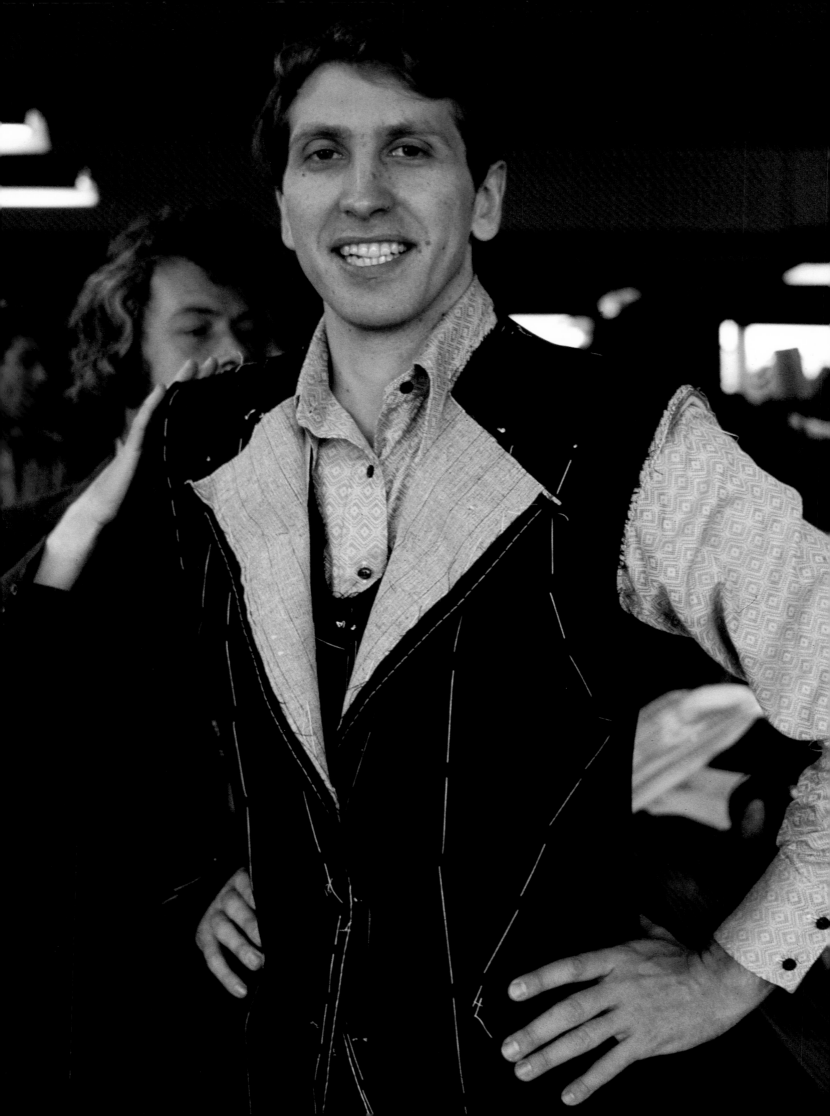

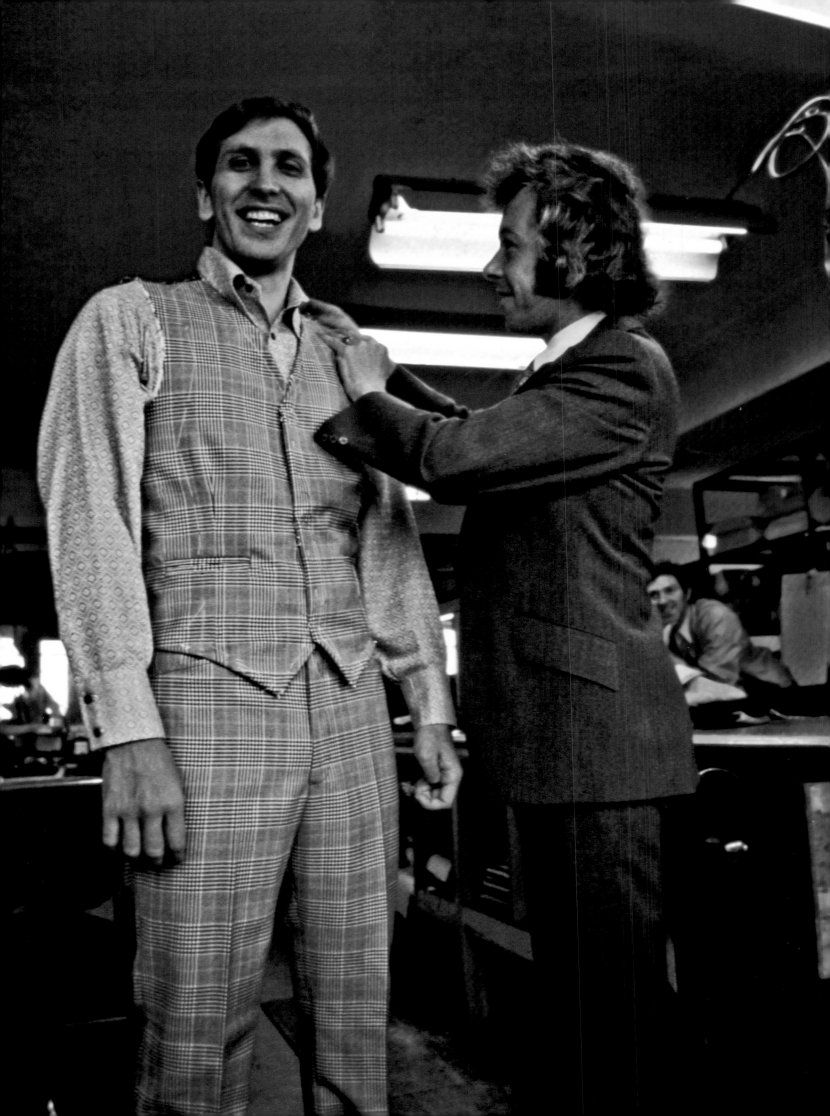

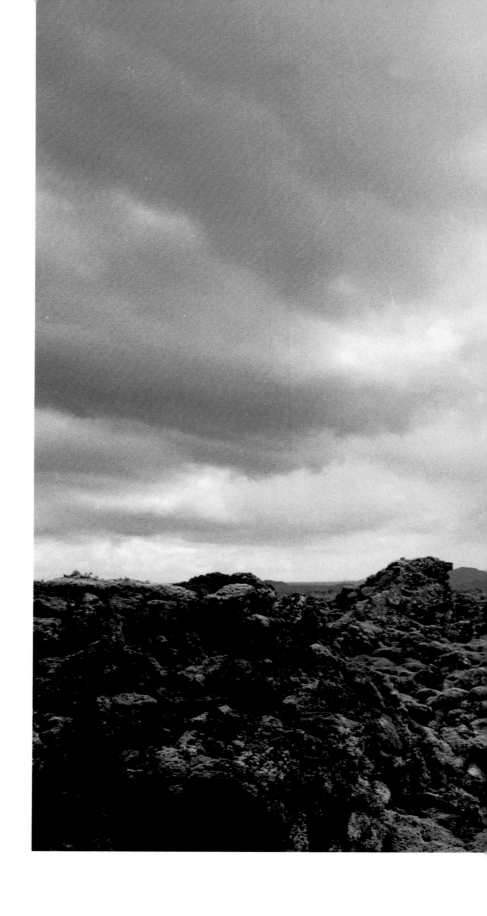

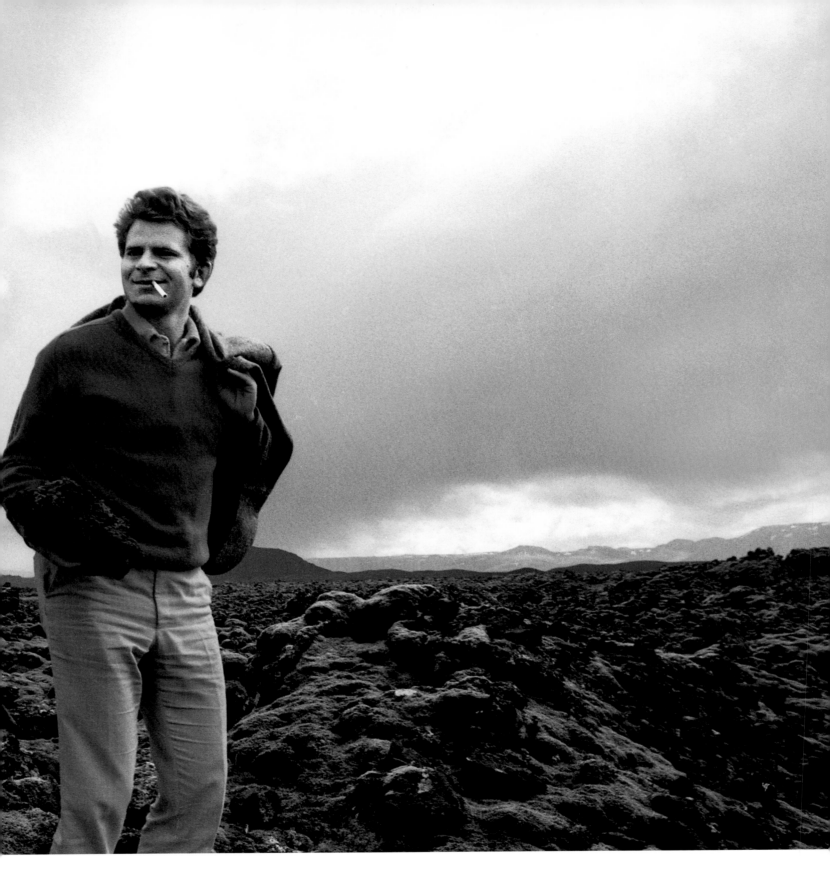

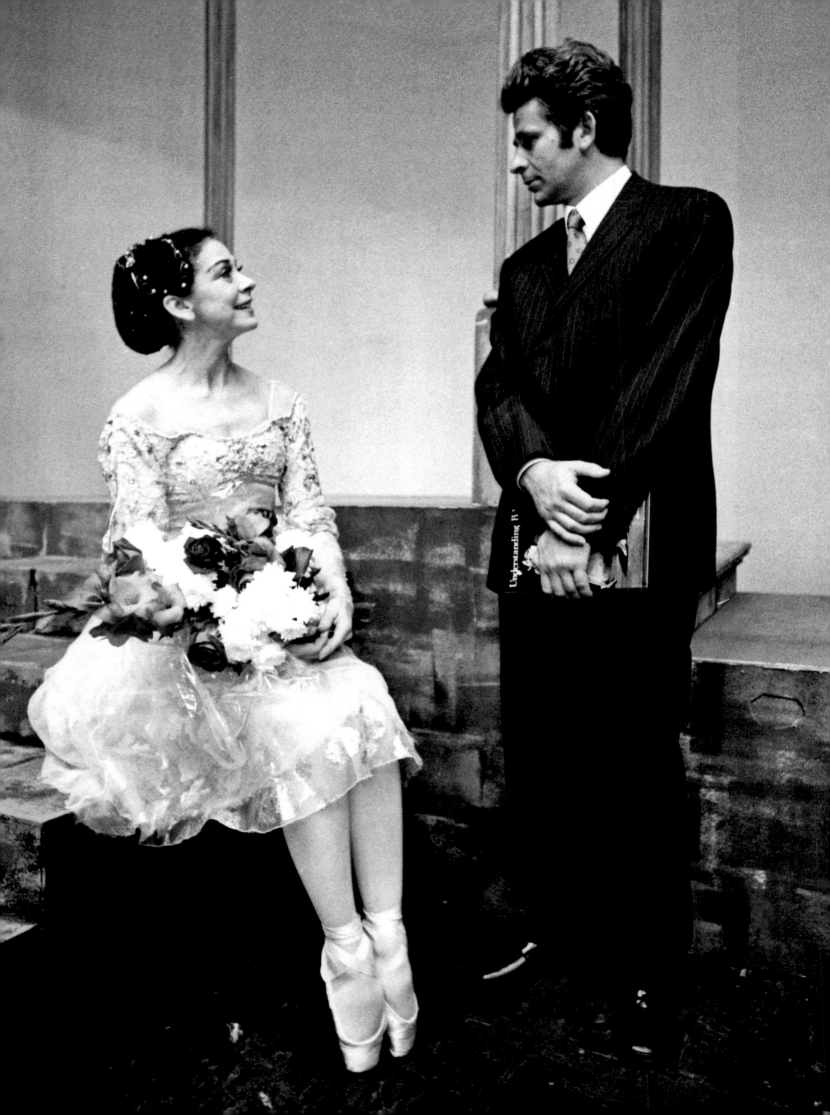

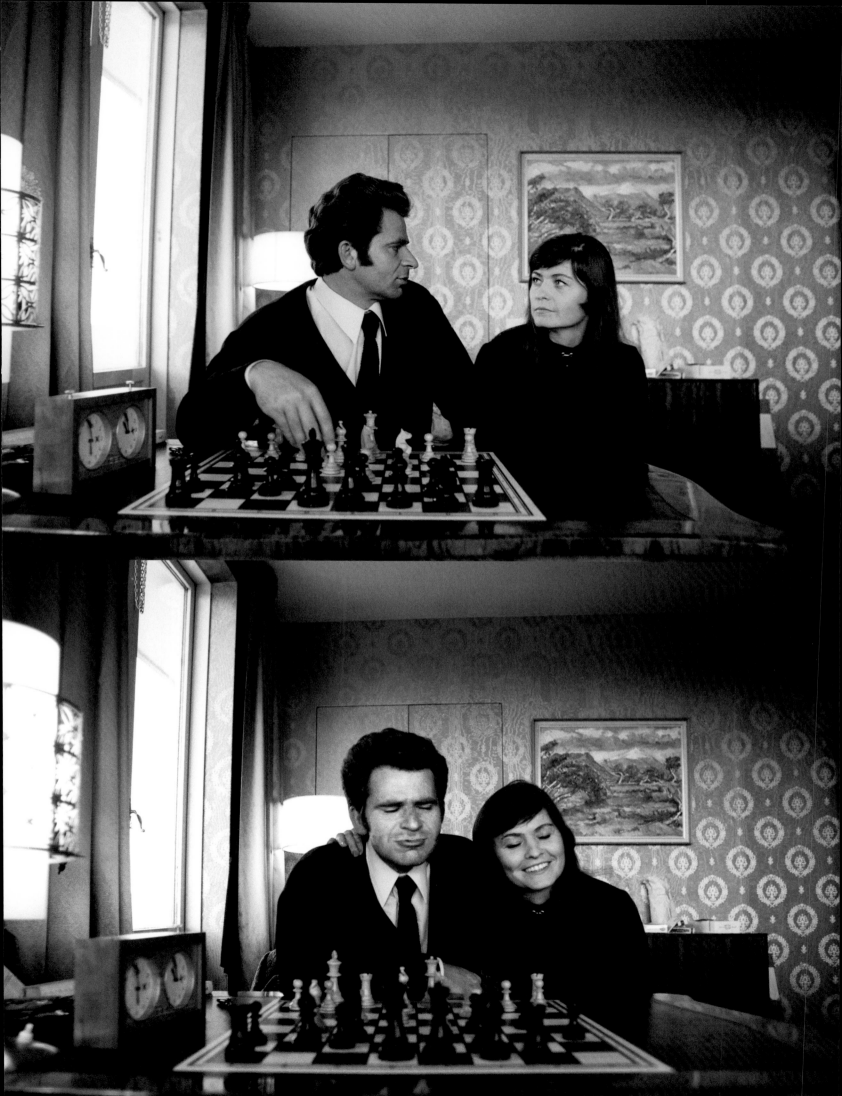

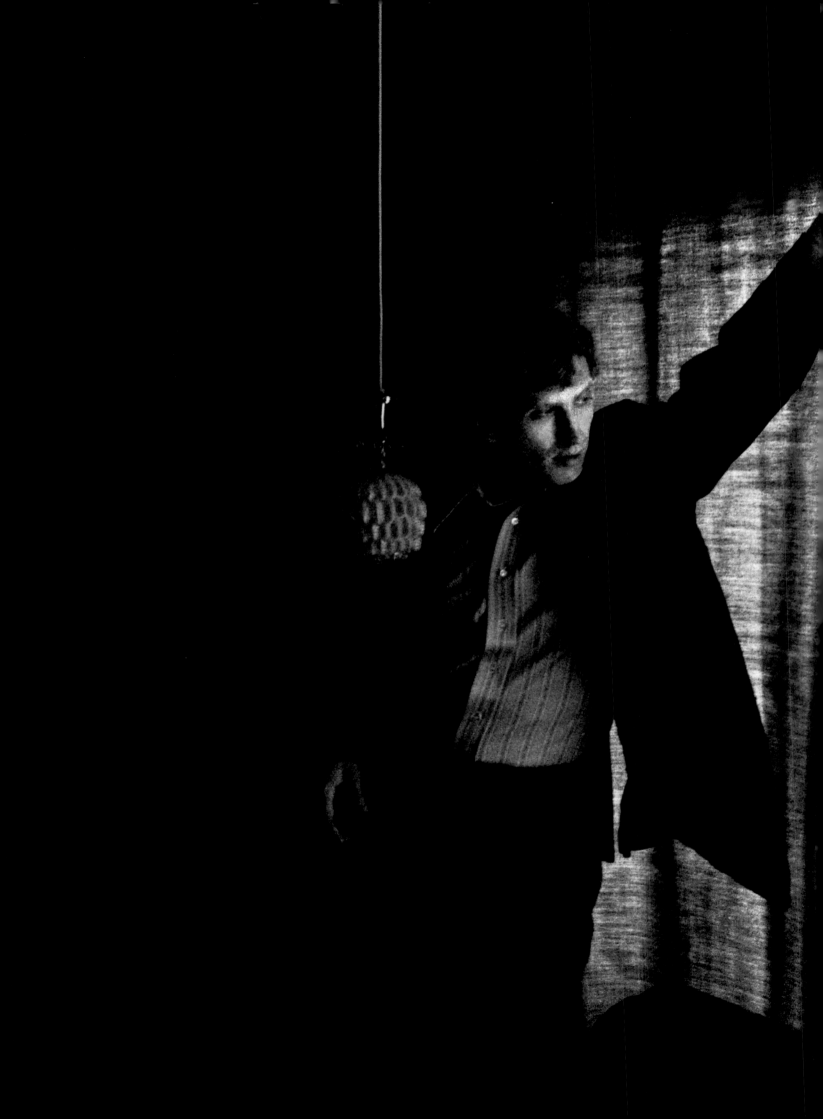

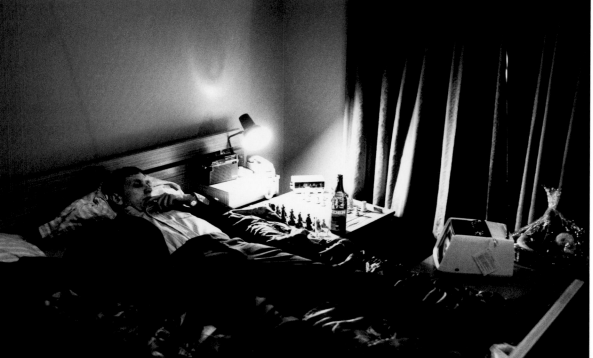

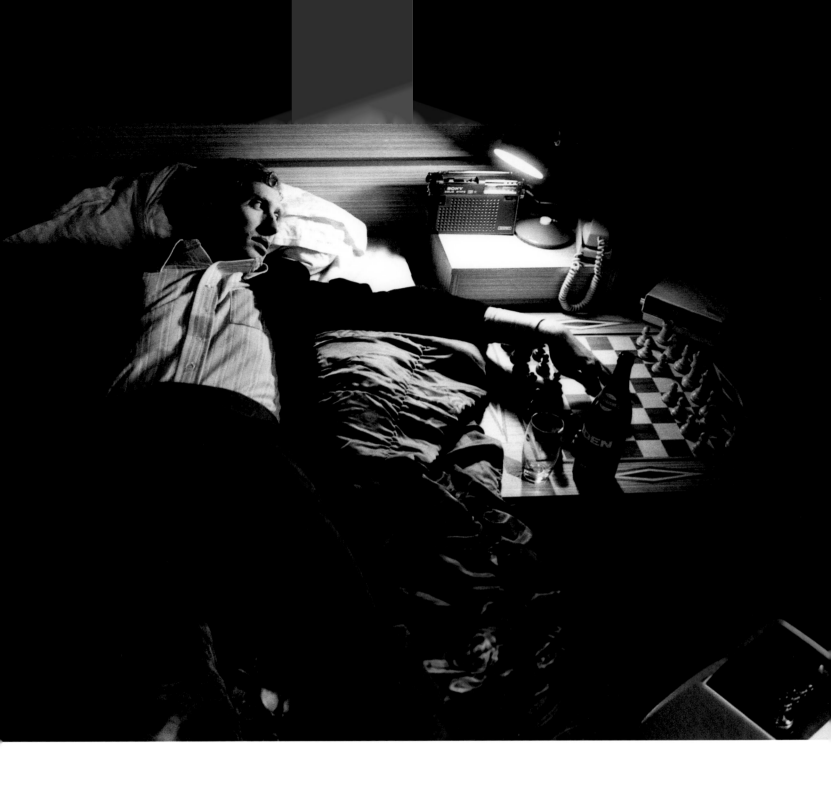

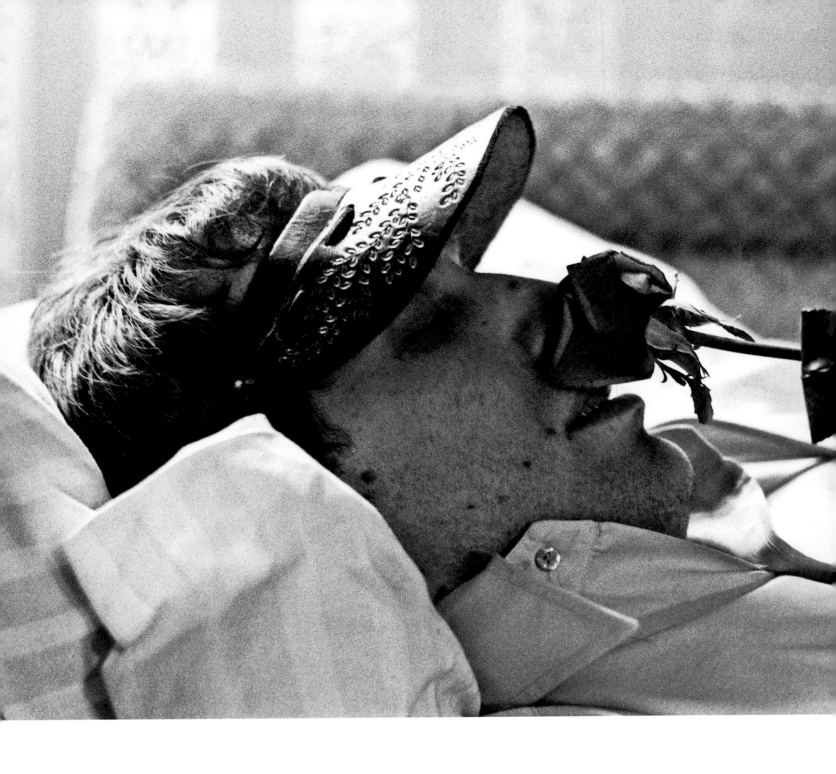

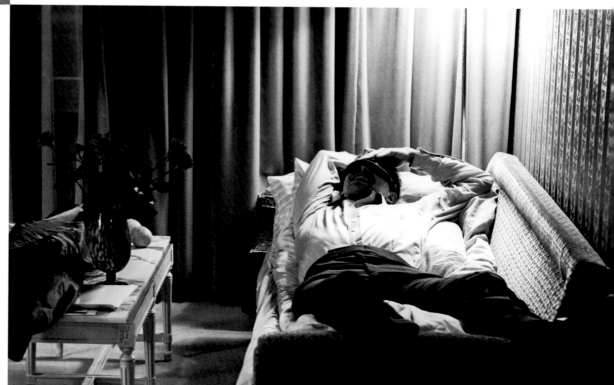

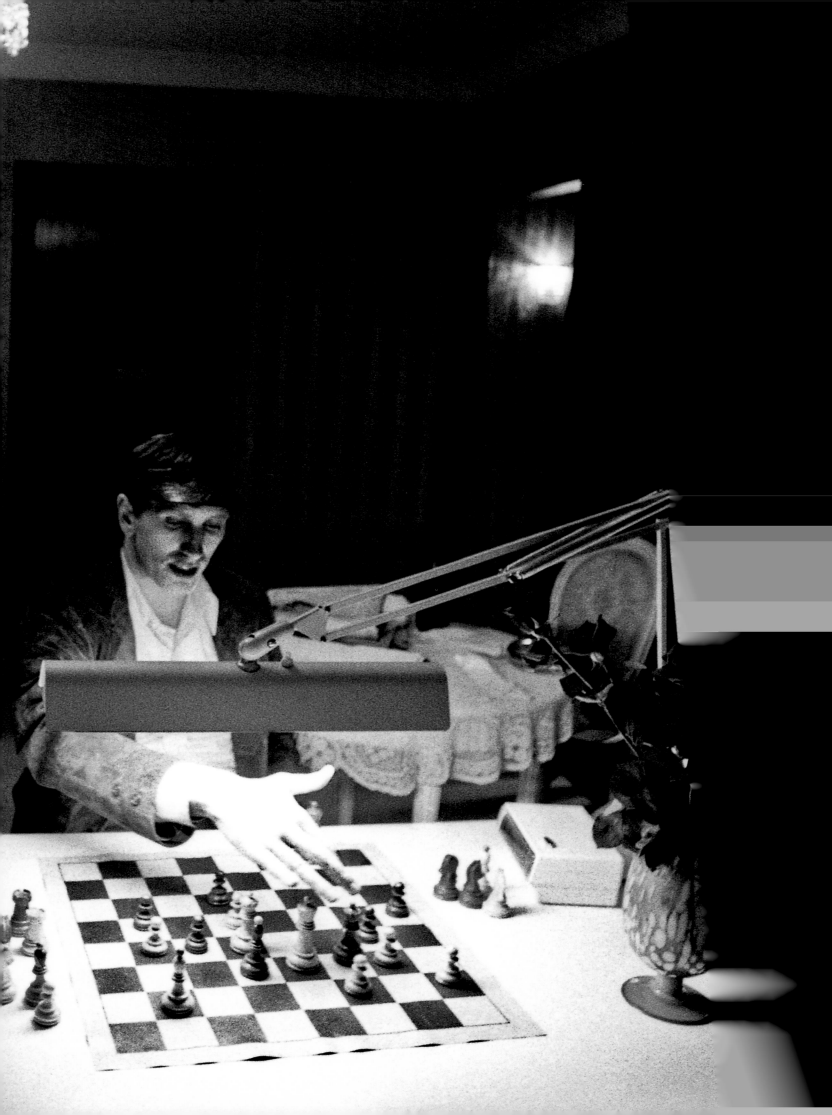

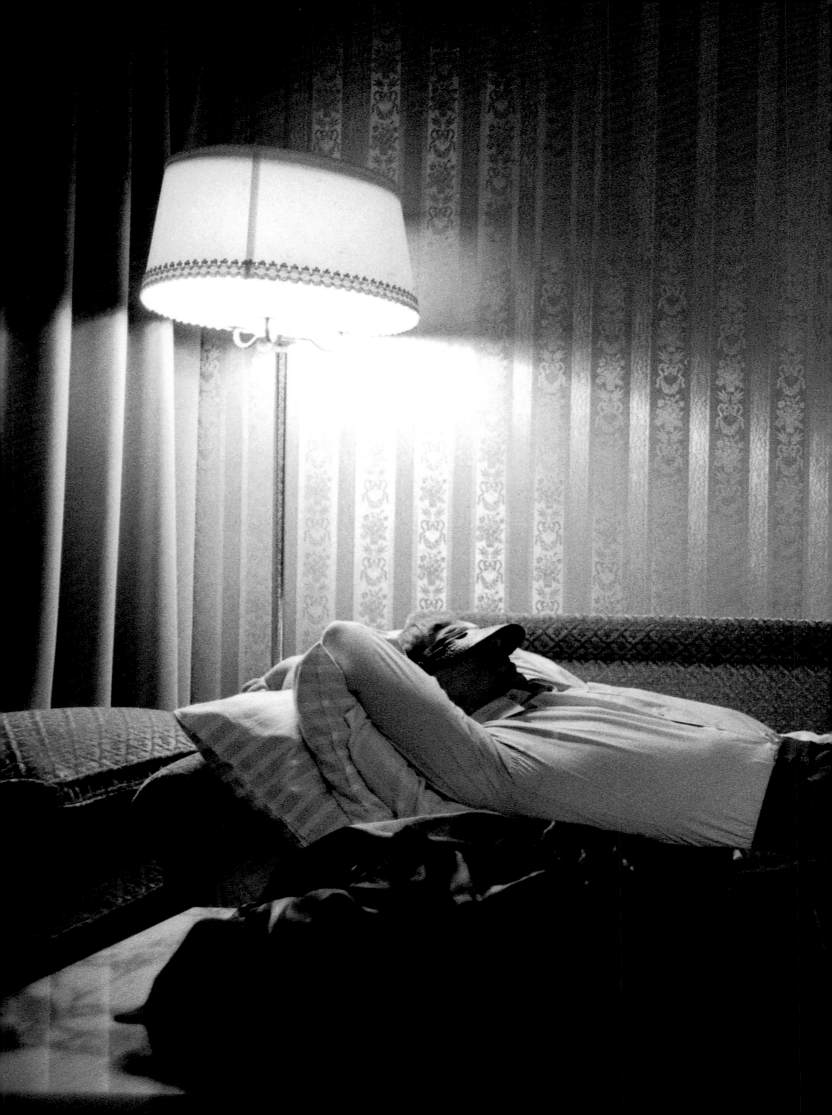

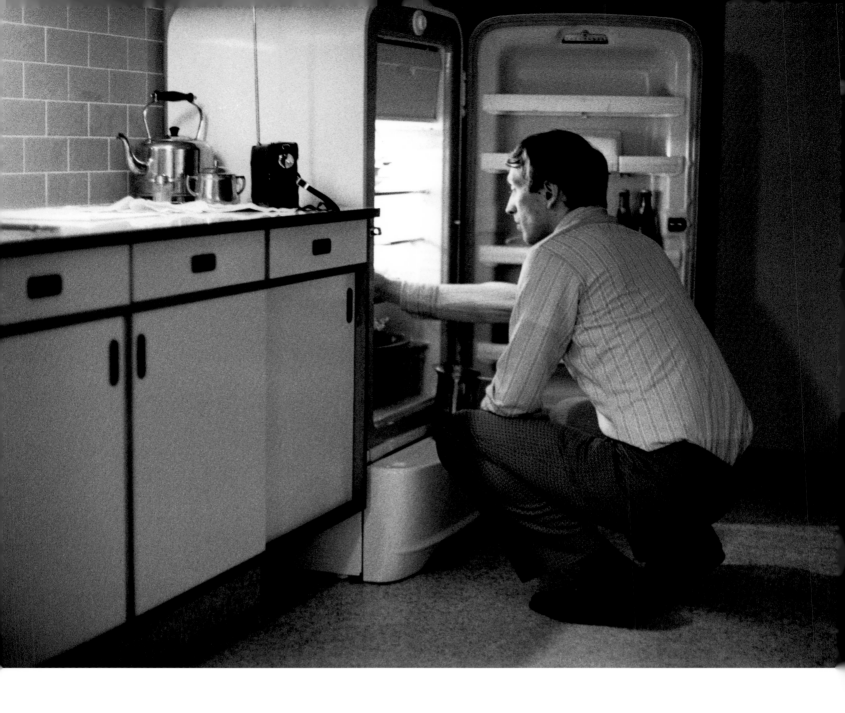

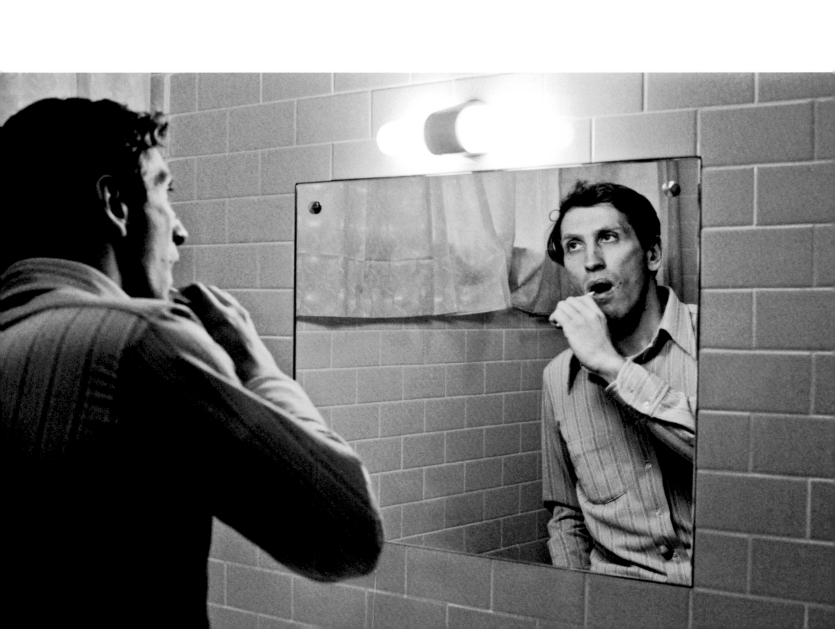

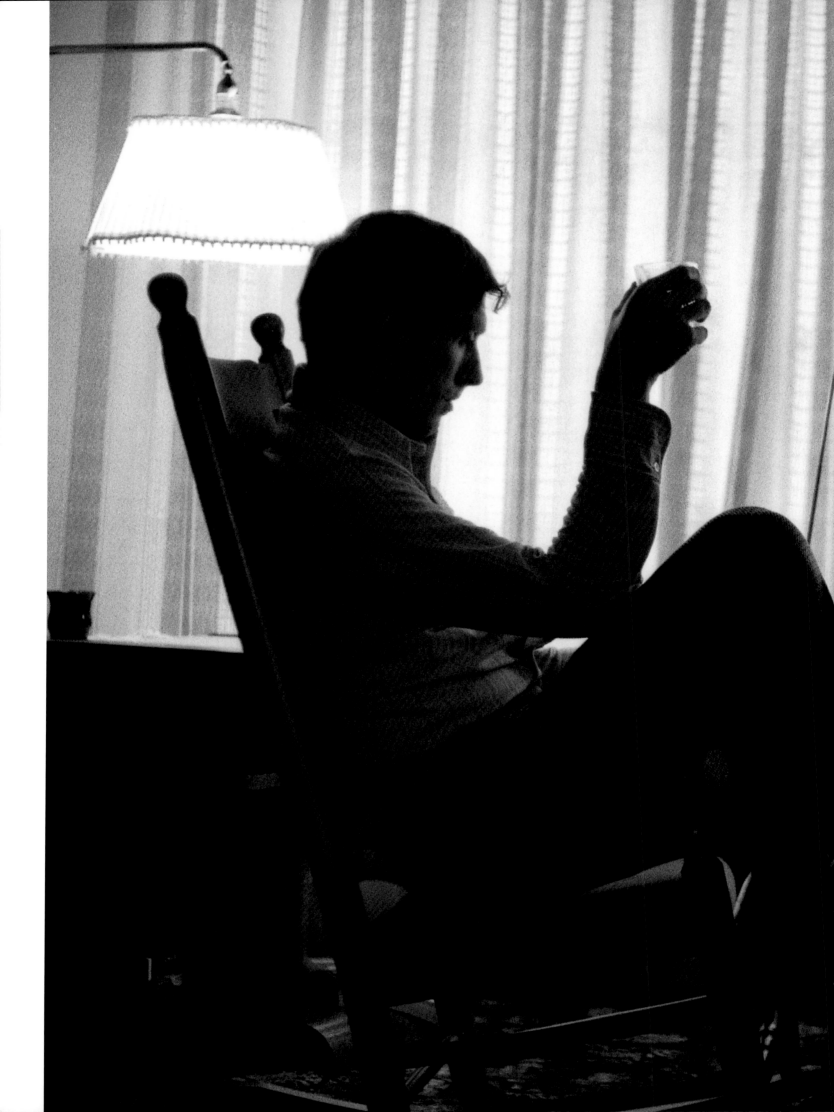

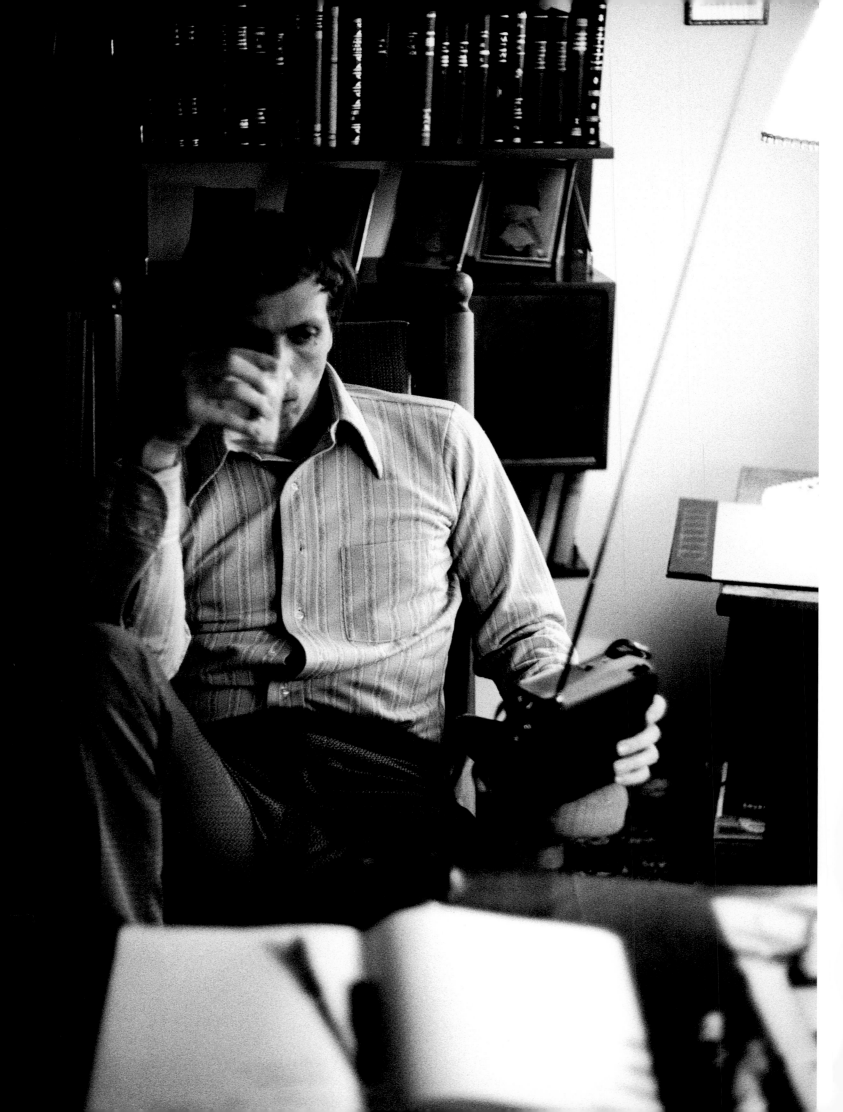

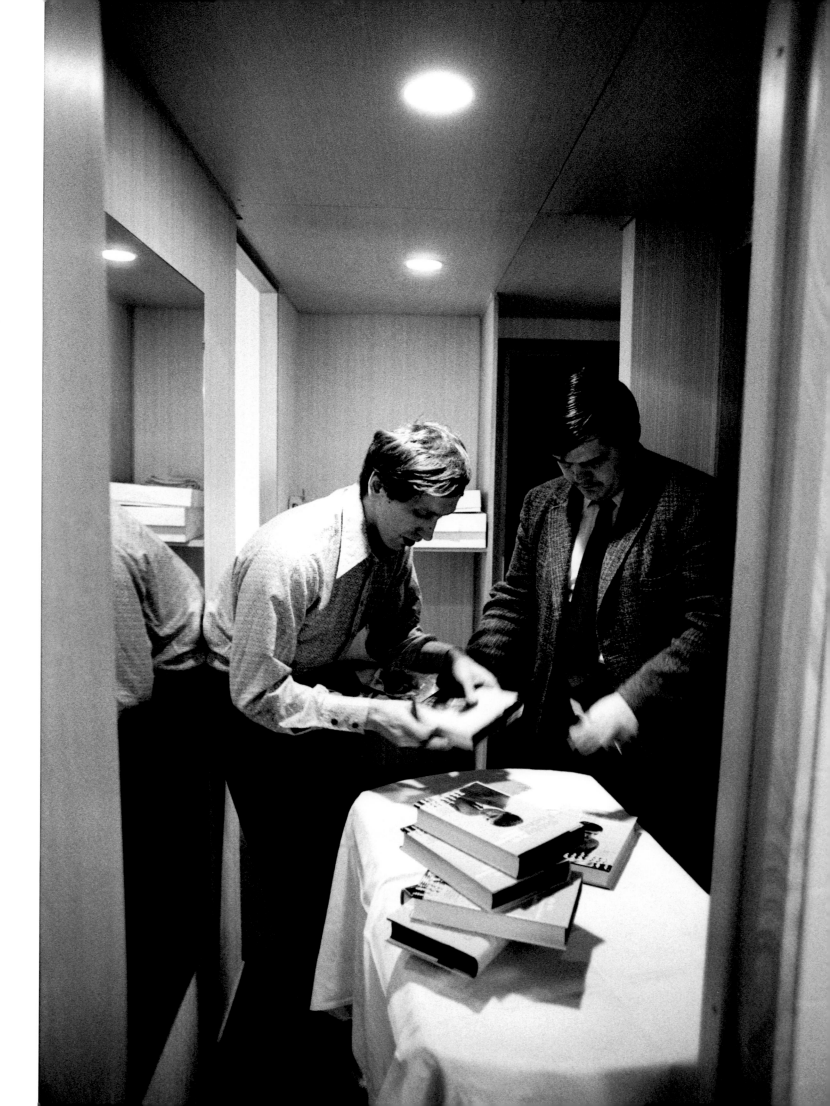

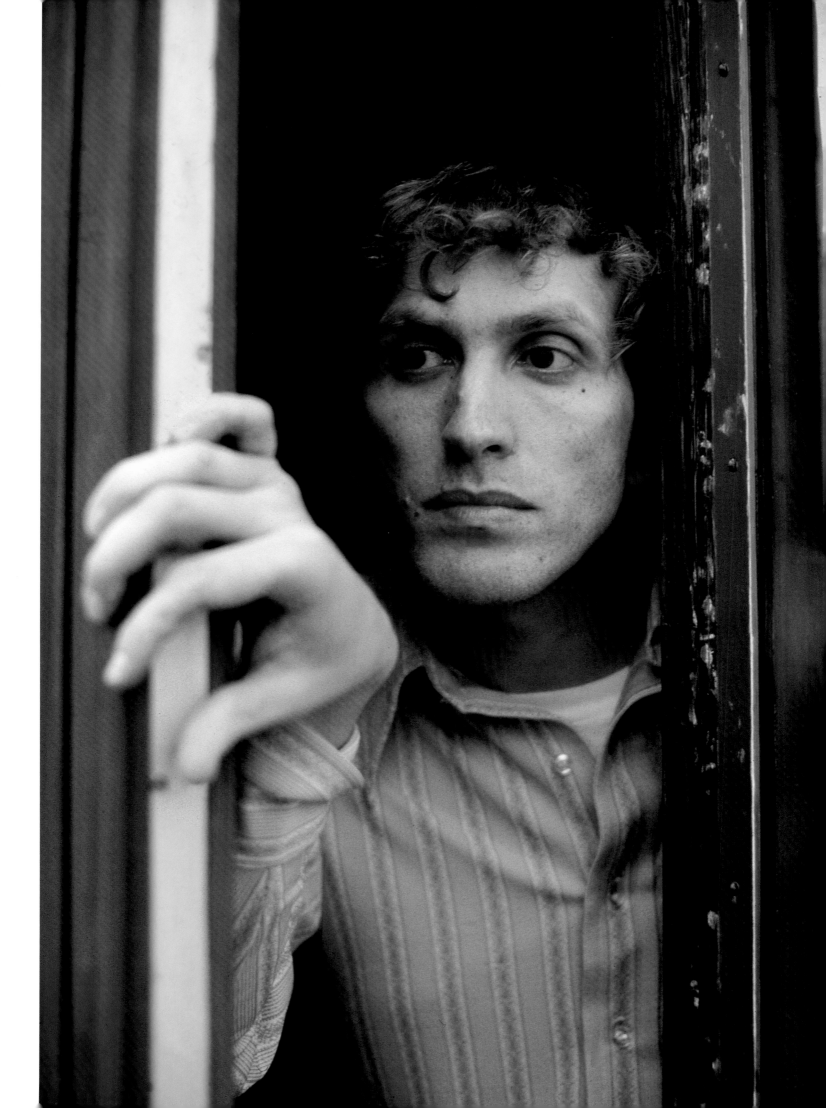

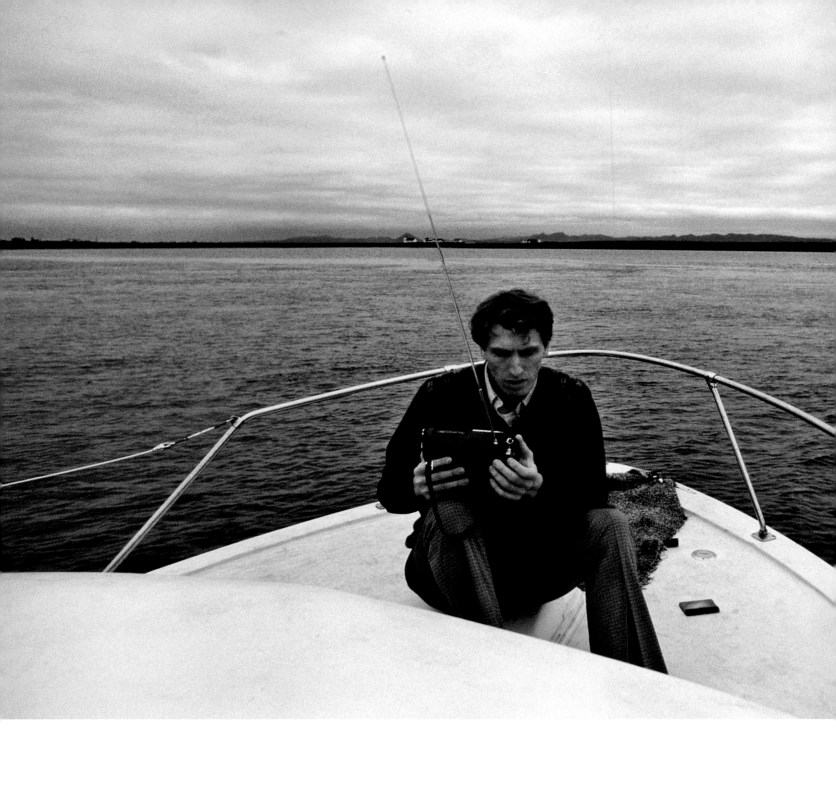

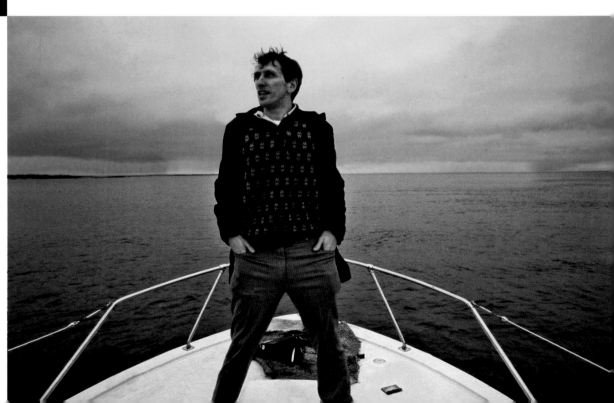

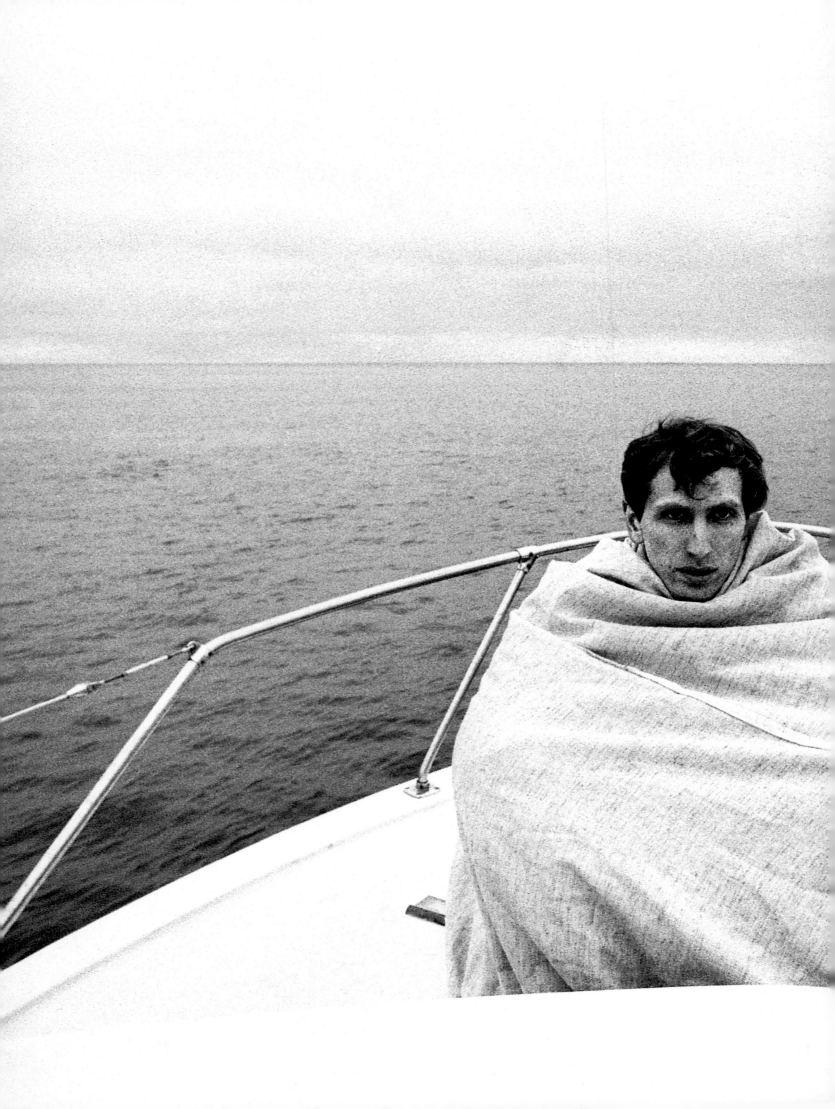

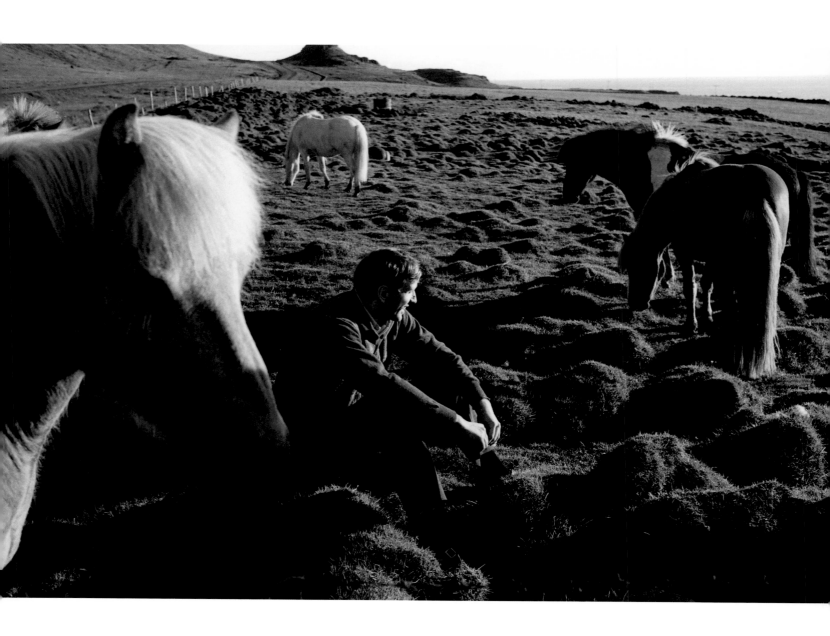

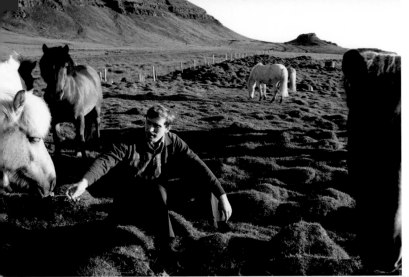
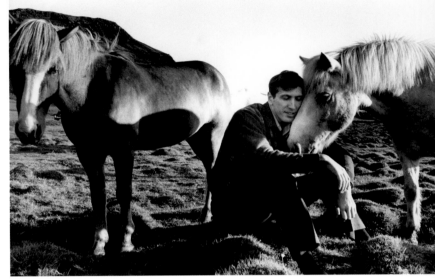
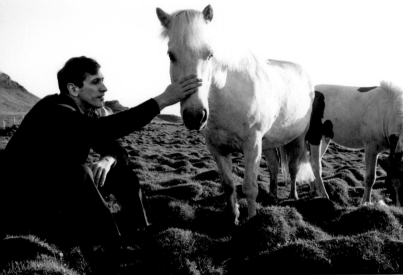
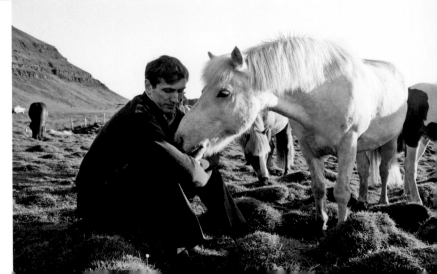

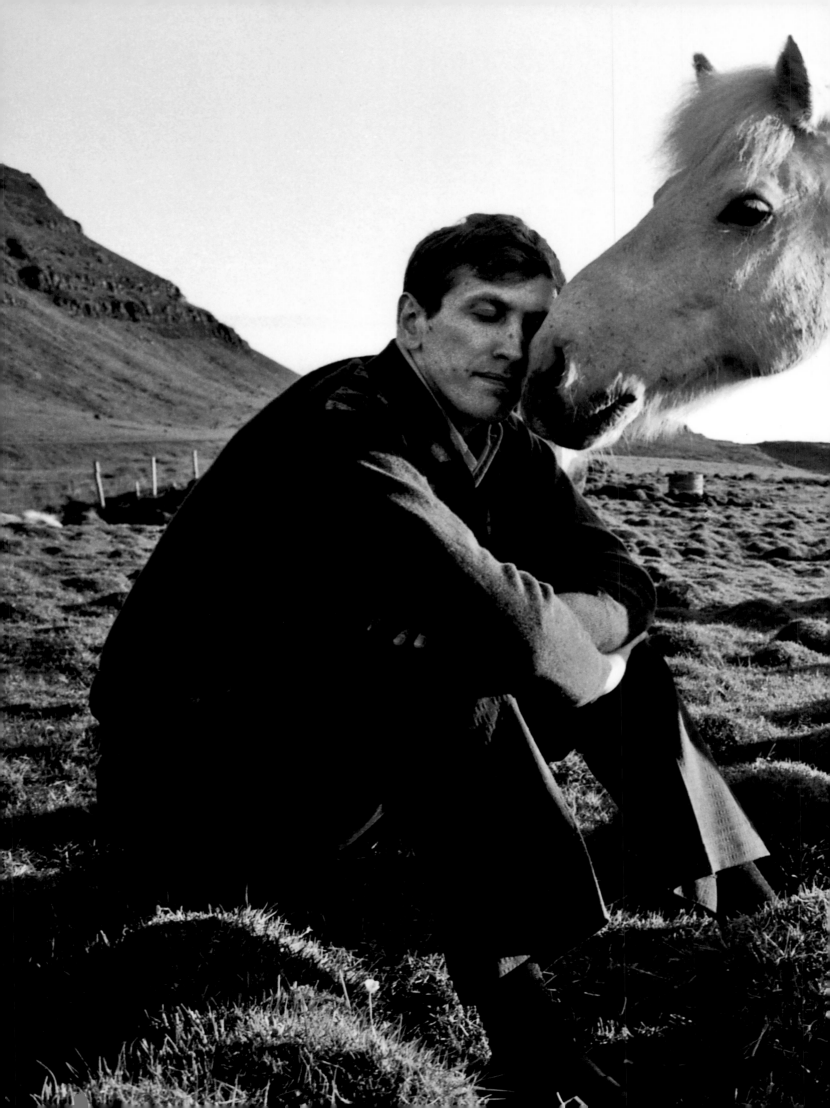

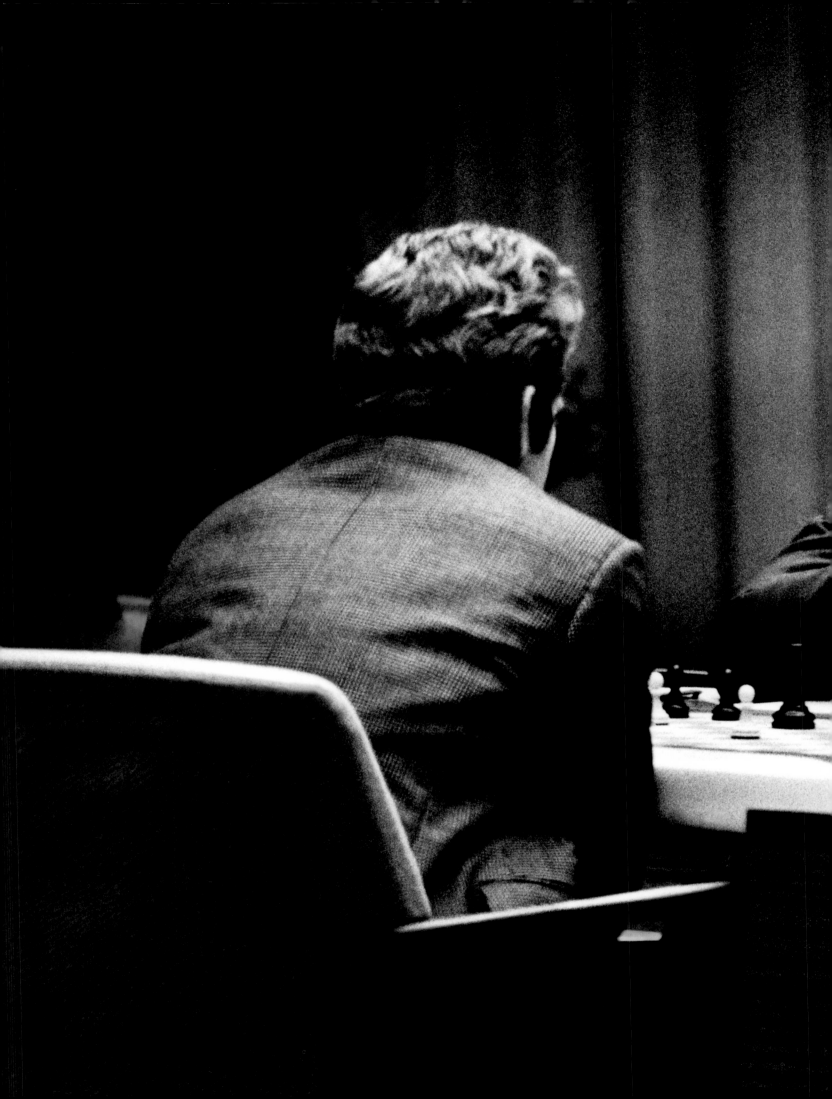

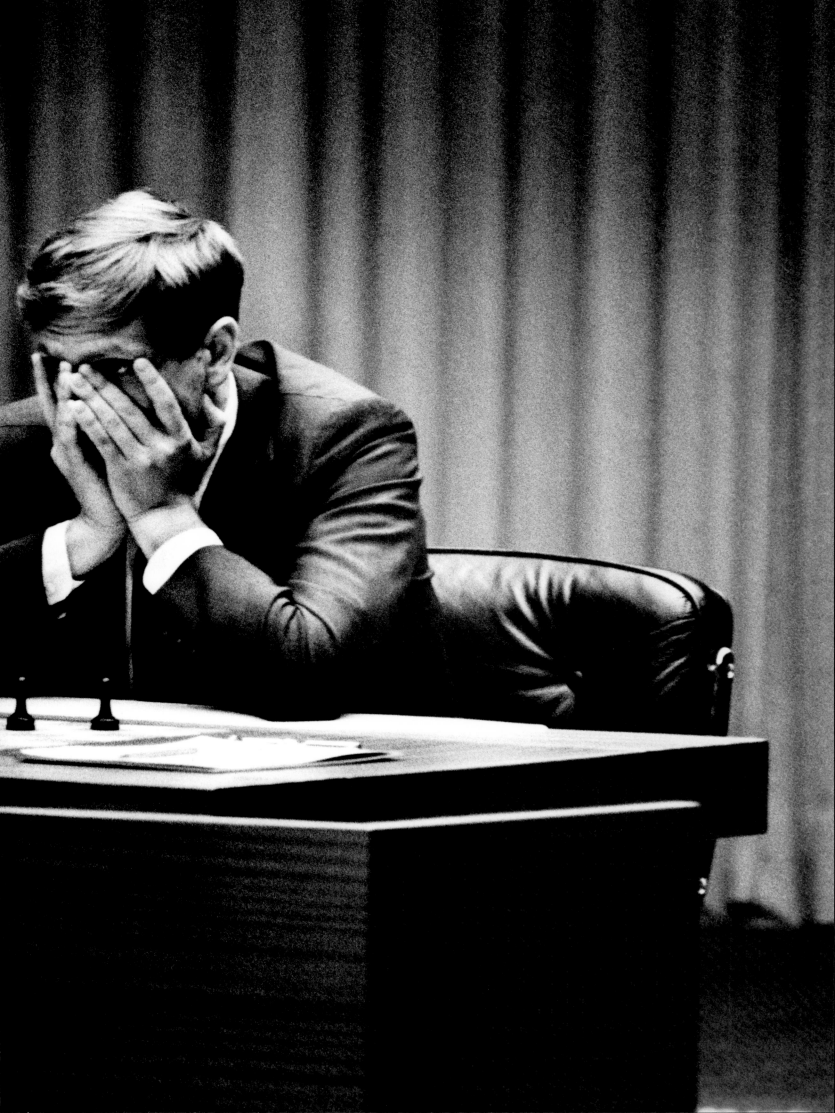

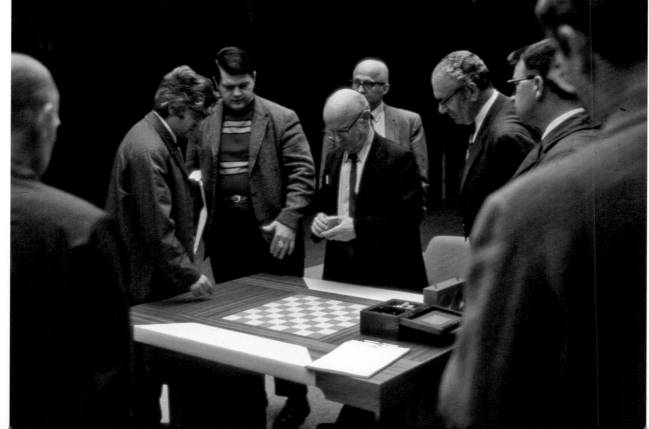

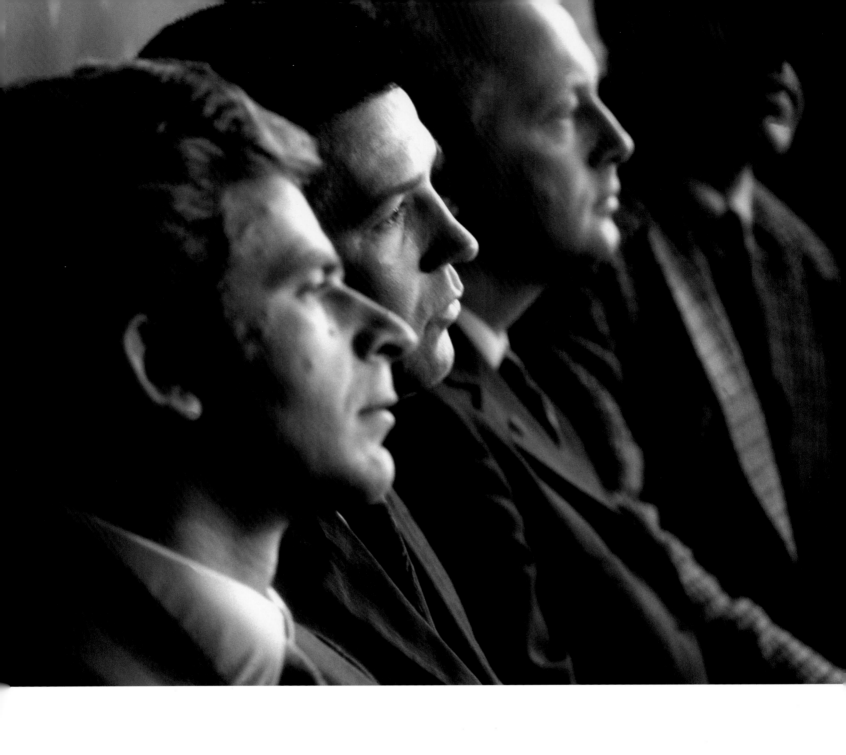

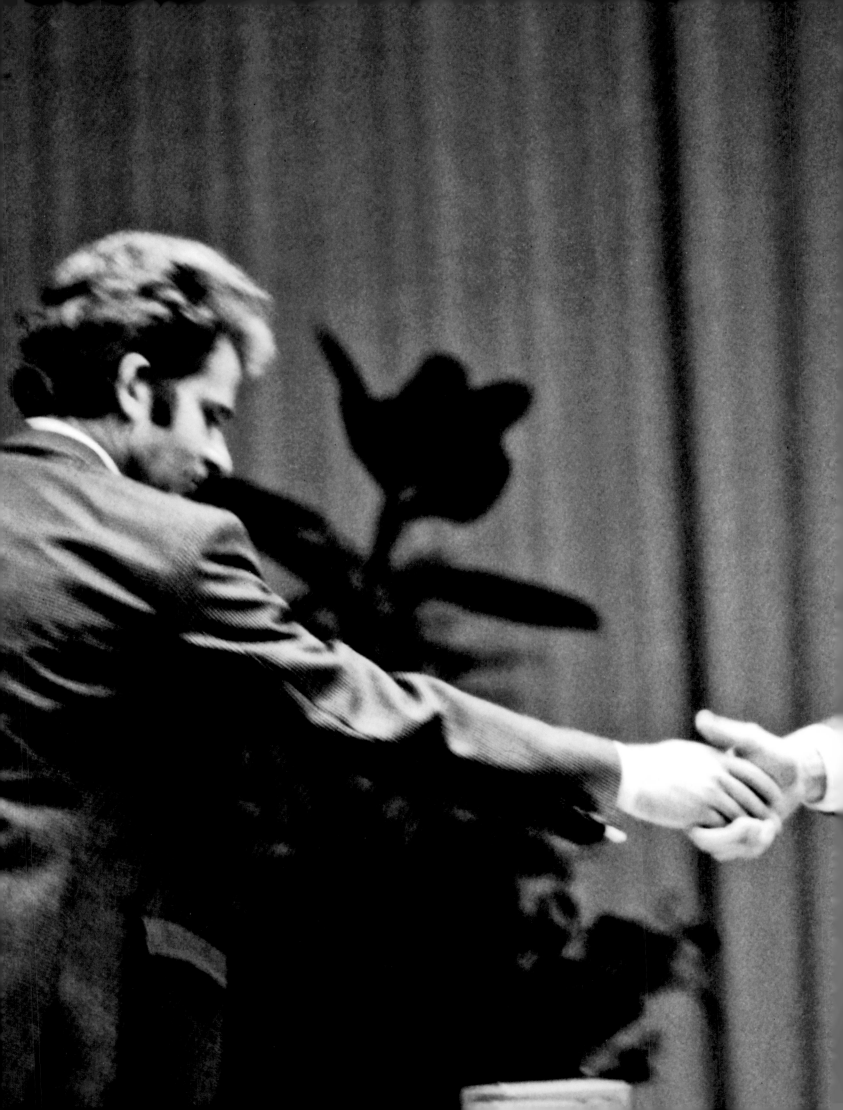

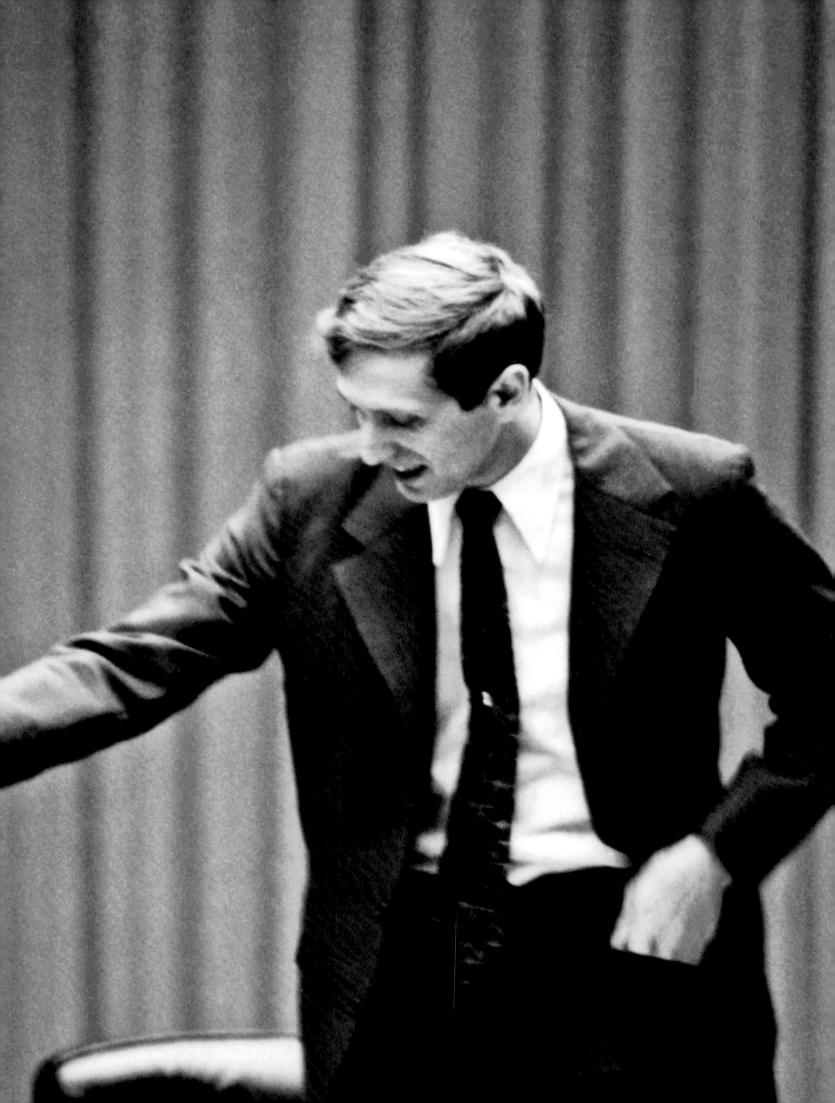

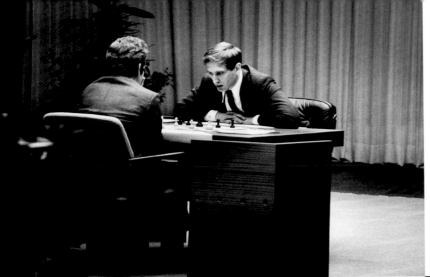

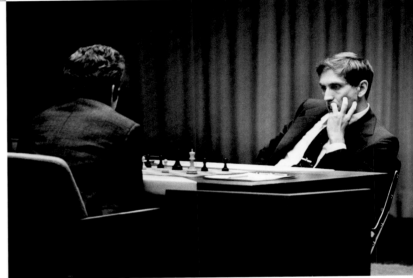

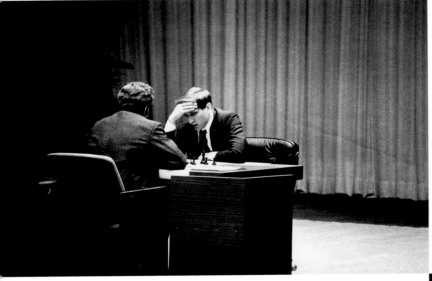

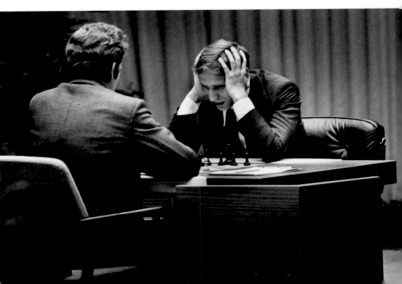

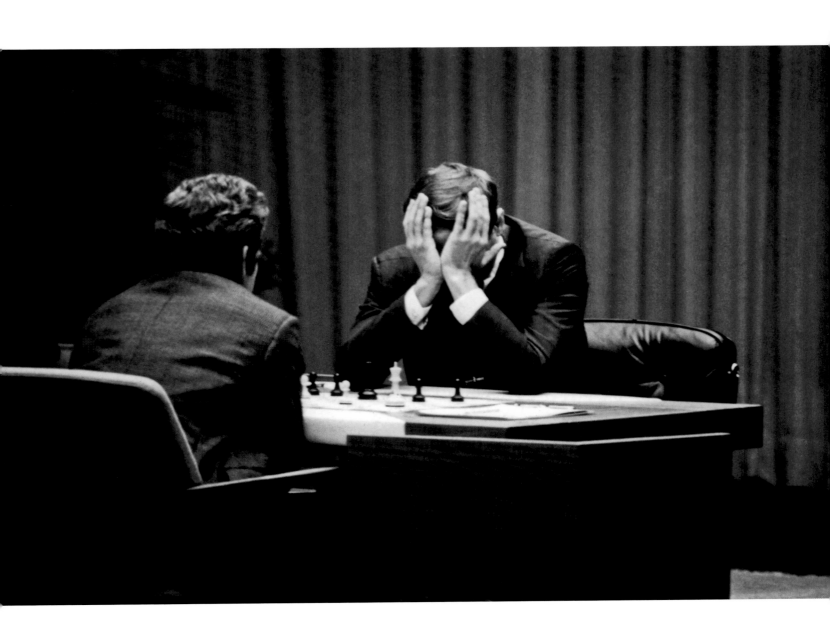

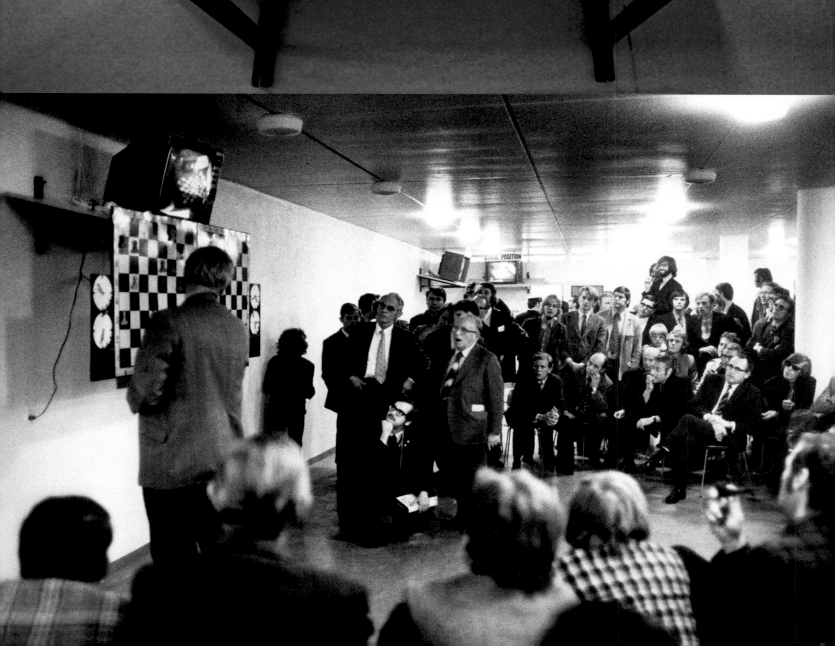

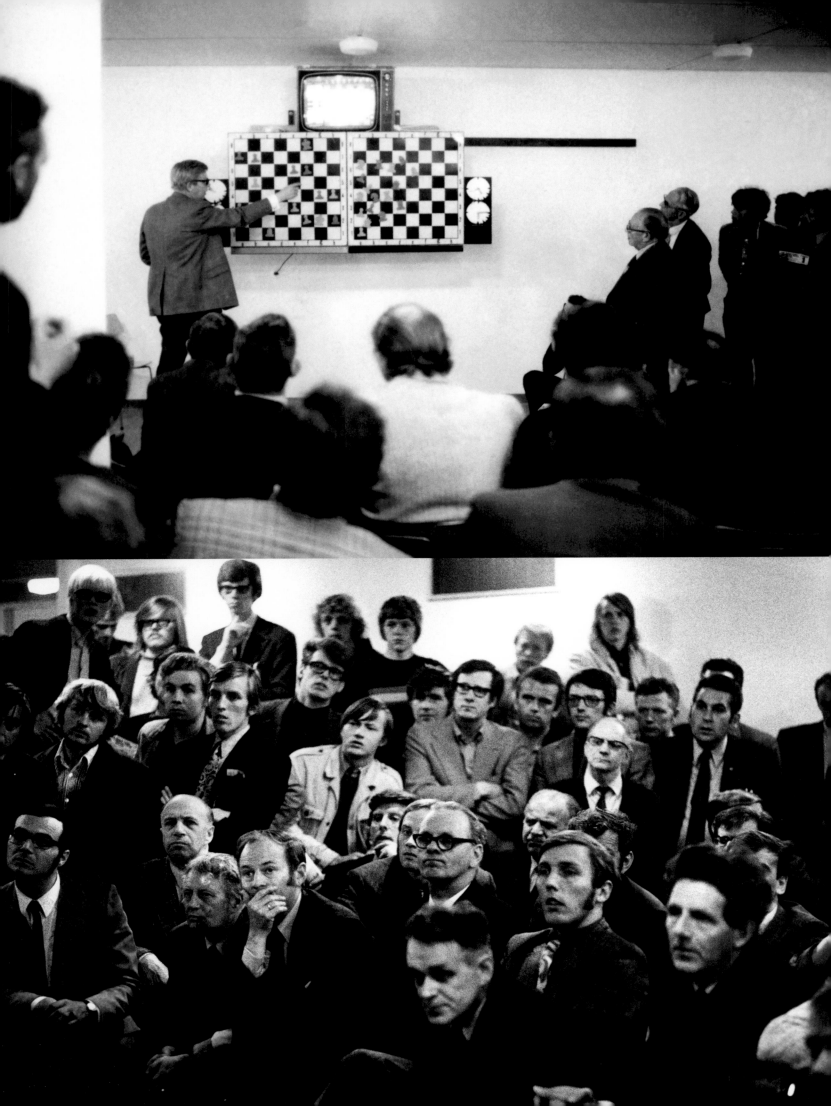

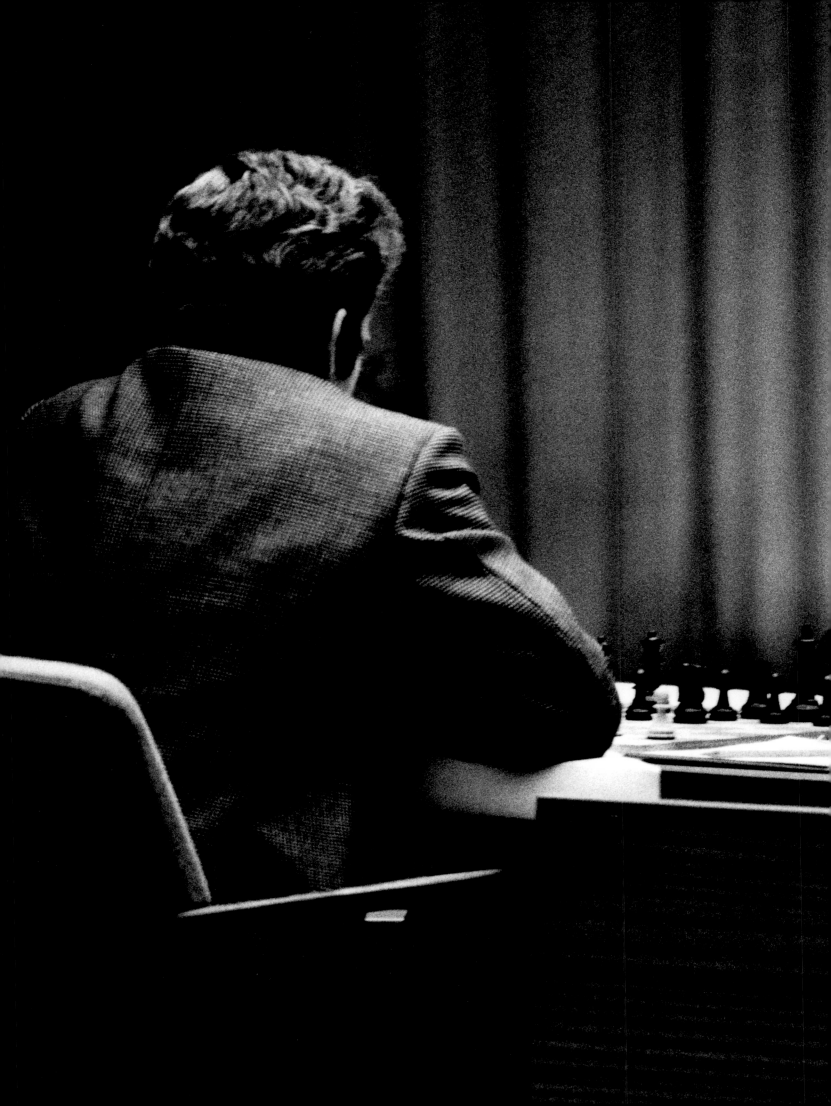

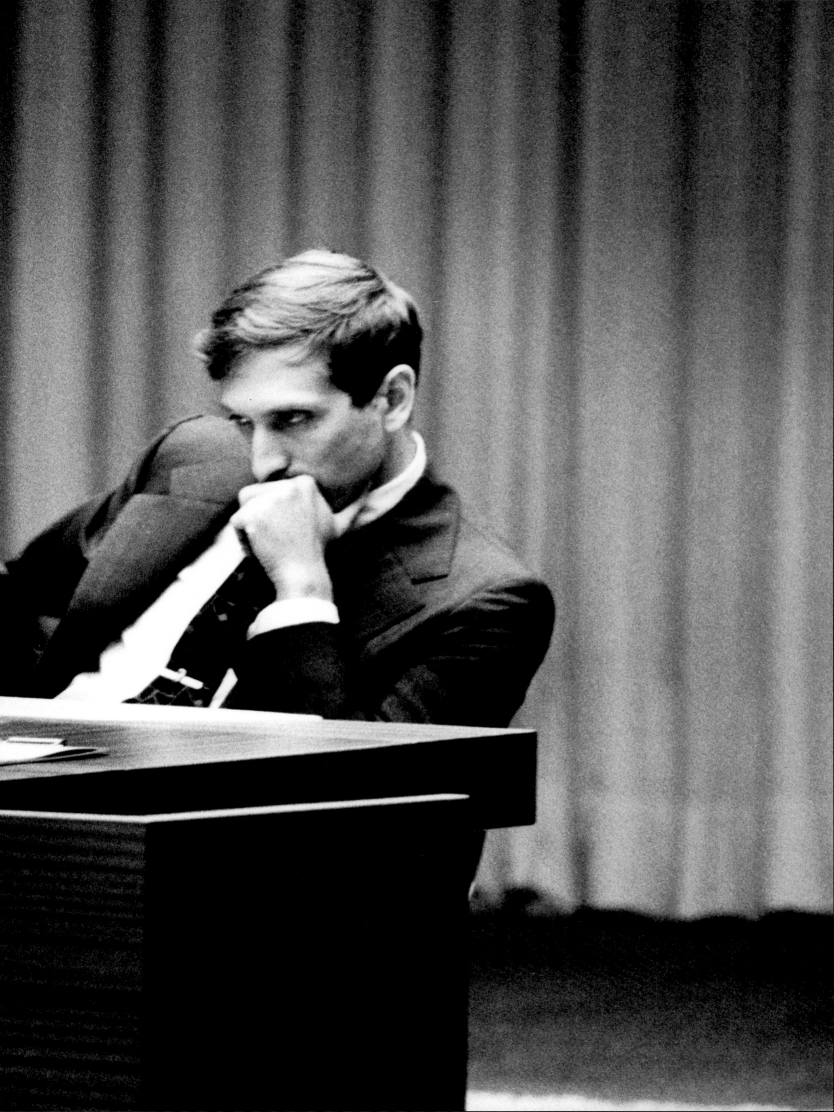

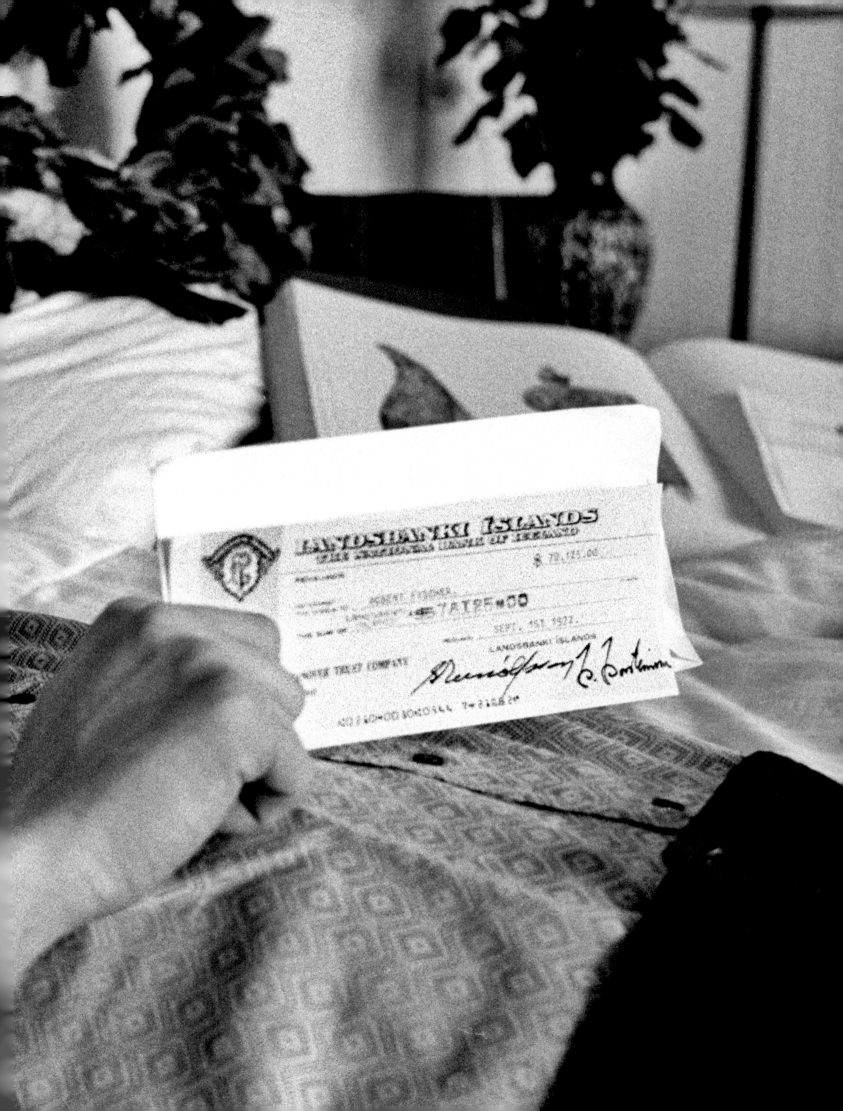

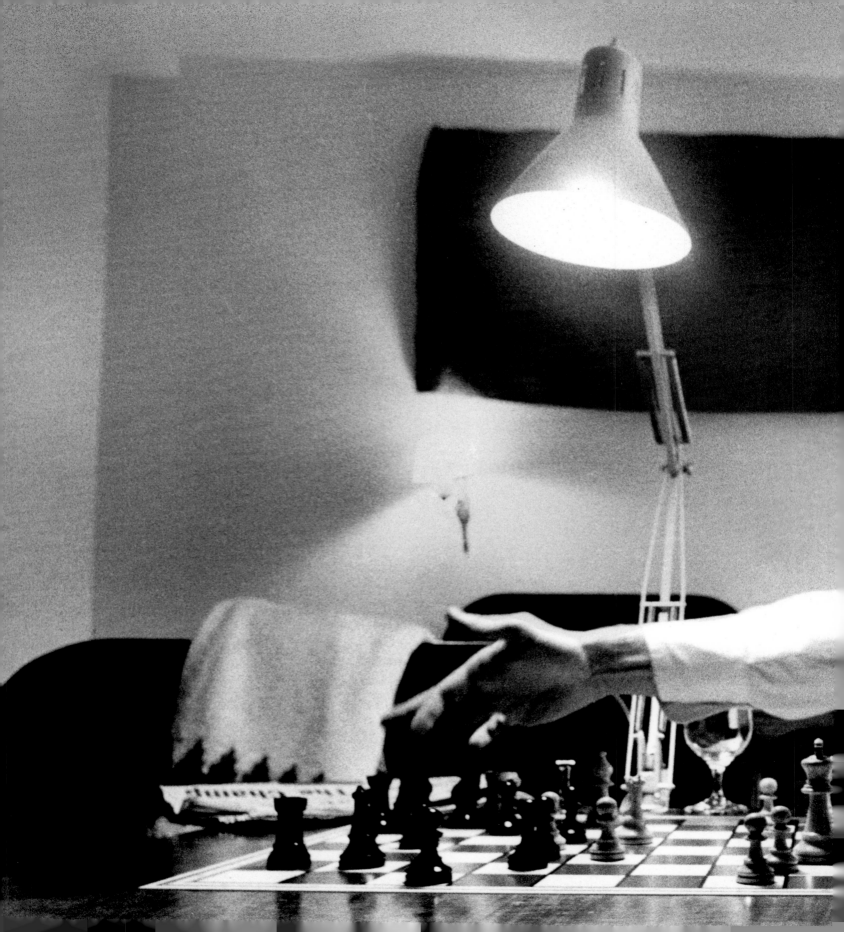

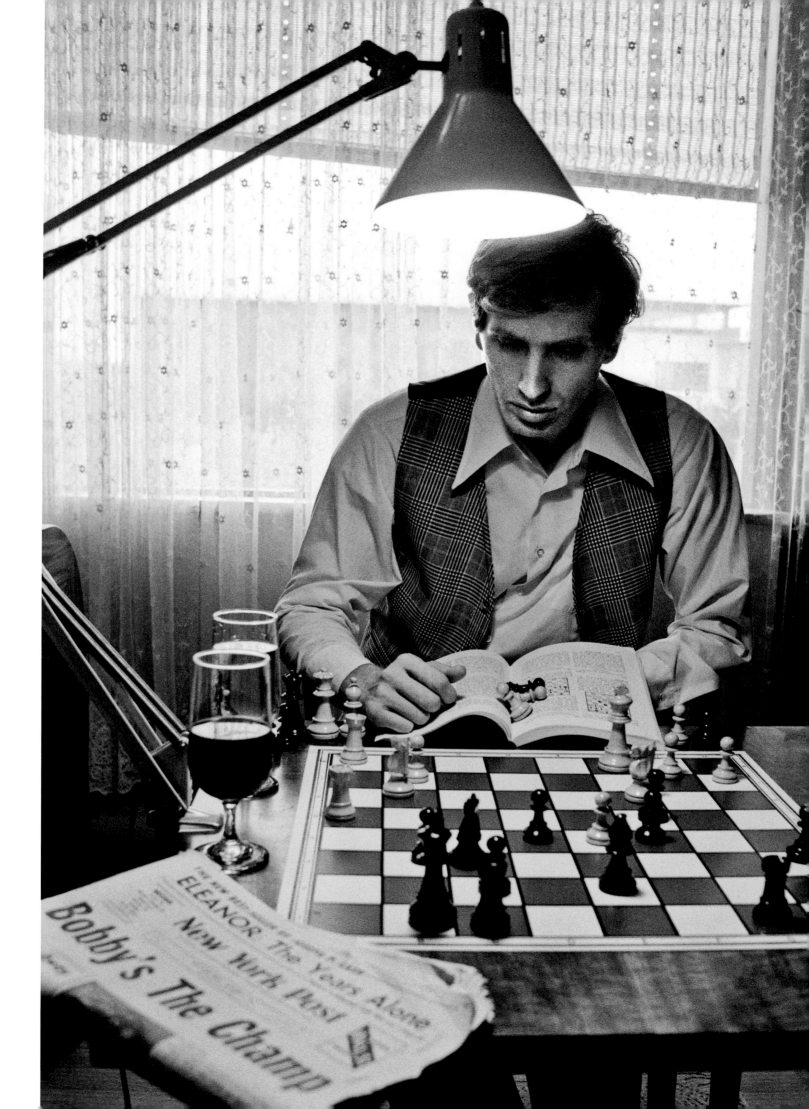

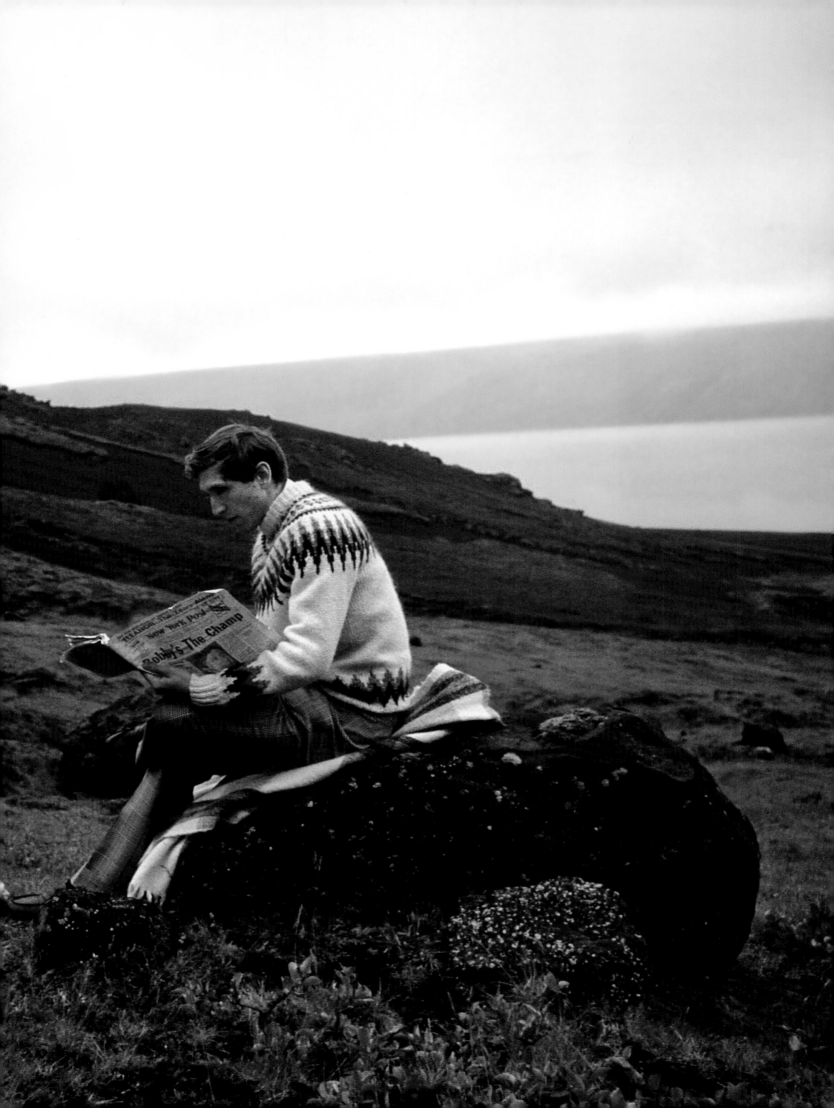

I probably knew Bobby at the best time in his life—in Argentina, at Grossinger's in New York, in Iceland, and for a time in California where he lived after the match. He was a tremendous athlete; loved animals and they loved him; knew more about chess than anyone, anywhere; studied hard and loved to teach children; enjoyed the company of pretty girls; was fascinated by world events; and was the world champion. In other words, when I knew him, Bobby had an almost perfect life.

What a stark contrast when you hear about the controversy surrounding his later years and see what his life became. It is quite shocking and sad. But when you take a look at my photographs you get a straightforward picture of what Bobby was like when I knew him.

No one can ever again write a word about chess without talking about Bobby Fischer. If this is controversial, so be it—I know and am sure that many who disdained him were those who Bobby would not do business with. He wasn't someone you could manipulate. He did what he did and that is what I photographed. That's what I hope the pictures show: complete transparency.

His country disowned him, a country he did so much for by single-handedly defeating the Russians during the Cold War and changing the image of America in the eyes of the world. Years later, what Bobby said about 9/11 was horrific, disgusting, and unconscionable, but I truly believe his ranting was due to his citizenship being revoked and a warrant being issued for his arrest by the U.S. after defeating Spassky in Yugoslavia in 1992. It must have been a terrible feeling. Others disagree and that is their prerogative. But the Bobby I knew and photographed is the one I will remember.

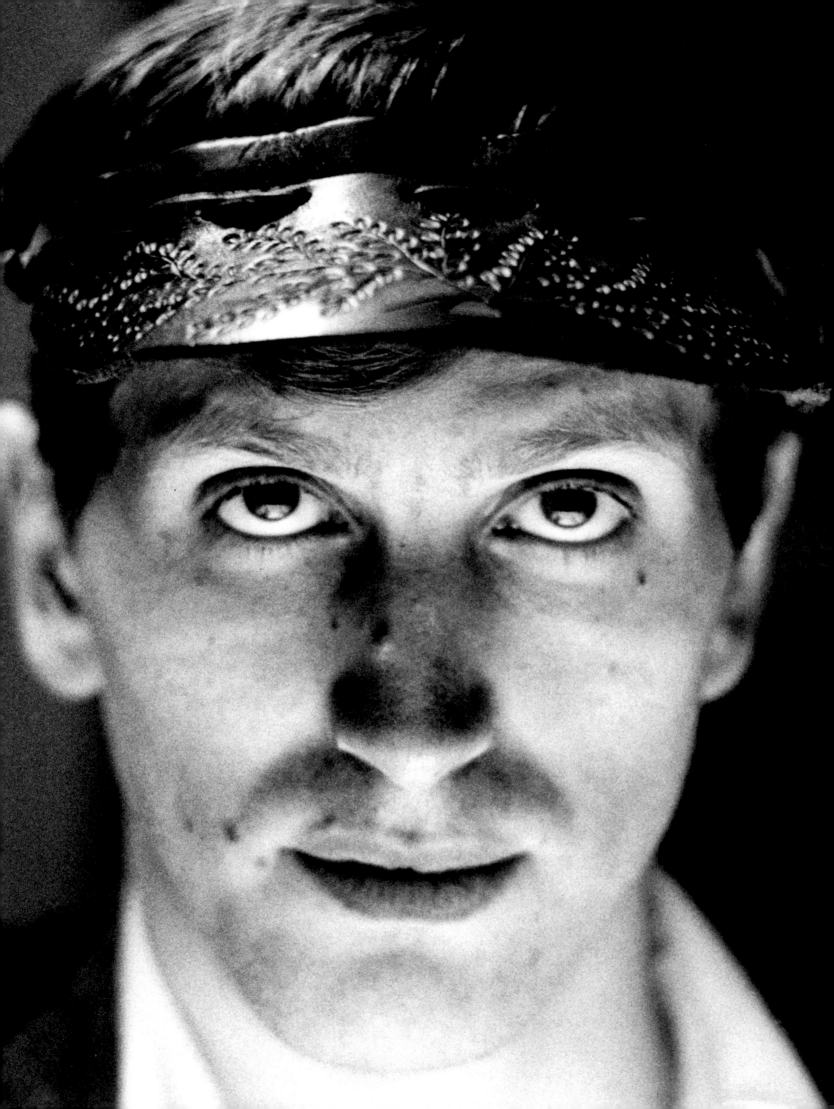

ACKNOWLEDGEMENTS

This book would not have been possible without the help of Brad Darrach, the extraordinary *LIFE* magazine writer who accompanied me to Buenos Aires, Grossinger's, and Iceland when I photographed Bobby Fischer.

To *LIFE* magazine photography editor Ron Bailey, who gave me the assignment of a lifetime, and to Sean Callahan, my point person from *LIFE* while I was in Iceland, thank you for your encouragement and support.

My very special thanks to CEO Daniel Power, Executive Publisher Craig Cohen, and Associate Publisher Wes Del Val, whose continued support in this our third collaboration has been invaluable and tremendously appreciated. And to Managing Editor Will Luckman whose editorial assistance was diligent and insightful. And my thanks to the other members of the powerHouse team Nina Ventura, Julien Khelif, Alex Martin, and Krzysztof Poluchowicz.

My thanks to the talented team of Stefanie Weigler and David Heasty of Triboro for their expertise and cooperation in designing the book.

To the elegant and cerebral John Loring whose instinctive brilliance can produce a little magic with every project he tackles, I am truly thankful for your ingenious help on this book.

And to Bobby Fischer, the most extraordinary man I have ever met and photographed, I am glad to have known you.

FIRST DAY COVER

REYKJAVIK

HEIMSMEISTARAEINVÍGI Í SKÁK

-2. VII. 1972